MANGA FASHION
ART SECRETS

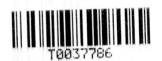

MANGA FASHION
ART SECRETS

THE ULTIMATE GUIDE TO
DRAWING AWESOME ARTWORK
IN THE MANGA STYLE

DALIA SHARAWNA

Search Press

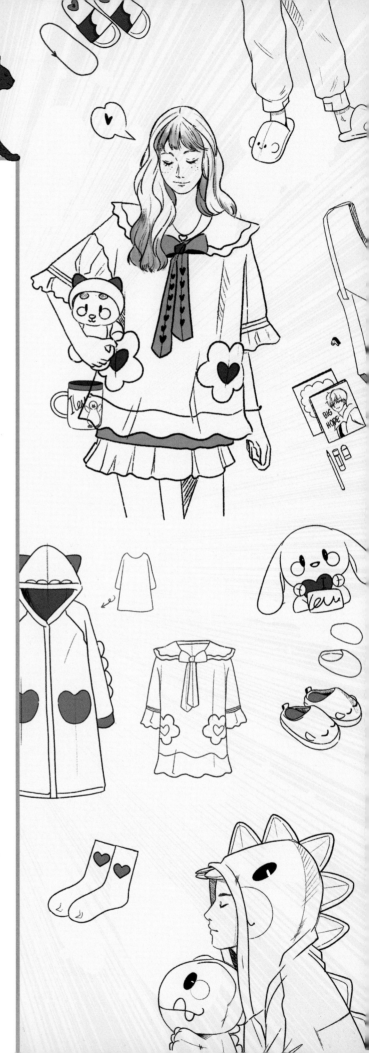

A QUARTO BOOK

Published in 2023 by
Search Press Ltd
Wellwood
North Farm Rd
Tunbridge Wells
Kent TN2 3DR

ISBN 978-1-80092-157-3
eBook 978-1-80093-141-1

Conceived, edited and designed by
Quarto Publishing, an imprint of Quarto
1 Triptych Place
London SE1 9SH
www.quarto.com

QUAR.421976

Editor	Charlene Fernandes
Copy editor	Katie Hardwicke
Managing Editor	Lesley Henderson
Designers	India Minter and Josse Pickard
Senior art editor	Rachel Cross
Illustrator	Dalia Sharawna
Deputy art director	Martina Calvio
Publisher	Lorraine Dickey

Printed in China

Shutterstock credits

Shutterstock.com/Yuravector;
Shutterstock.com/I_Mak; Shutterstock.com/Alex Leo

CONTENTS

MEET DALIA

I am Dalia, a self-taught Palestinian artist and the author of *Manga Art Secrets*. I grew up loving to draw, and have been drawing for more than 11 years – it is something that I enjoy doing every day as a form of self-expression. I love fashion, too, and tend to get inspired by it when drawing, and you may notice an emphasis on clothing in the characters that I draw. My go-to style is streetwear but I'm constantly exploring and drawing other fashion trends.

In *Manga Fashion Art Secrets*, I want to show you how to draw clothes in a manga style that conveys the personality, backstory and mood of your characters. Through step-by-step instructions and sharing some of the secrets that I have learned in my drawing journey, you will discover how to draw different fashion styles, from casual and cosy everyday wear to beautiful Japanese kimonos or a ballet tutu. All you need to get started is a pencil and paper, and by following my guiding hand you will hopefully find the learning journey to drawing manga clothes an enjoyable one. For more inspiration and ideas, check out my drawings on my Instagram @drawing_dalia.

TOOLS AND MATERIALS

Before you begin creating your manga character you'll need to prepare your drawing equipment. I started out with a standard 2HB pencil that we used at school, and worked on printer paper and, while I have a few more pencils now, I still don't believe that investing in expensive tools is necessary. Good tools help in drawing but you can still achieve great effects without spending a fortune – invest time rather than money, learn the right drawing techniques and principles, and keep practising!

ERASER AND SHARPENER

As well as removing any errors, an eraser is also essential for lifting off your light guidelines. I like to use two erasers in different sizes: a large, soft gum or a putty eraser that you can shape to make changes in outlines. A pencil sharpener is a handy tool to have in your kit, too; I prefer to use a sharpened pencil for precision.

Avoid using erasers that leave coloured marks behind.

PENCILS

The hardness of a pencil lead determines the type of line and tone that it makes, and this is graded on an HB scale from the palest, hardest grade – 9H – to the darkest, softest grade – 9B. In the middle, between HB and H, is F, and this is the grade that I like to use for outlines. I then use HB, 2B and 8B pencils to go from light to dark. Try various pencils to find the preferred hardness that works for you.

A sketchbook is ideal for when the mood strikes and you want to catch a pose or idea quickly, or for developing a character's style. Work up final drawings on loose sheets of paper.

PAPER

You can draw on any paper, and there is a whole range to choose from that varies in thickness, texture and colour. I tend to use standard 110gsm weight paper, which is somewhere in the middle of the quality range. The surface is smooth and the pencil can move easily. I like to use a small A5 sketchbook so that I can carry it with me everywhere. But other sizes may suit your style, so explore what is available.

COLOURED PENCILS

Coloured pencils are a great tool for adding colour in controlled ways, plus why not try using watercolour pencils – these are great for light washes of colour when you add water with a brush.

DRAWING THE FACE

Starting with the face means you can customise your character through subtle changes in their facial features or expressions, exploring aspects of their style or personality to give them individual characteristics that differentiate them from others.

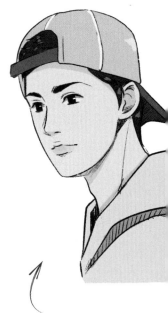

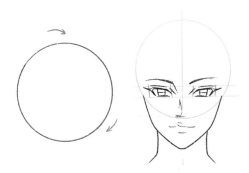

1 To draw a head from the front, start with a circle that acts as a guide for the whole face. The top of the circle represents the top of the head and the upper portion of the face.

2 Next, add the jaw by drawing a vertical line that divides the face in half, taking the line beyond the circle to the tip of the chin. Now blend the sides of the face with the chin.

Use these same principles when drawing the head at different angles or from different viewpoints.

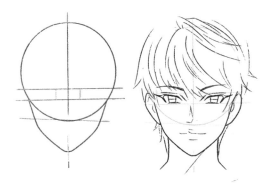
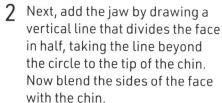
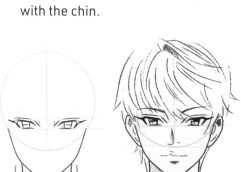

3 Divide the face with horizontal lines to help you position the eyes, nose and mouth. Draw lines roughly a third of the way up from the bottom of the circle for the eyes. Add a horizontal line across the bottom of the circle to mark the tip of the nose, with the mouth beneath.

4 Finally, add the neck; this helps position the head on the body. Start the neck using the guidelines for the base of the nose as the starting point, then extend them to the shoulders, keeping the lines symmetrical.

DRAWING THE BODY

In order to draw clothes realistically, you need to have an understanding of the shapes and proportions of the body beneath. Some clothes will have a wide fit that only require you to match the overall body proportions whereas other, more tight-fitting clothes will reveal the musculature and natural curves of the body's outline.

MALE TORSOS

Start with a trapezoid shape that is wider at the top (the shoulders) and narrows at the base (the waist). Add a vertical dividing line down the centre to split the body into a roughly symmetrical shape. Indicate the waist with gentle curves and position the shoulders, adding defined muscles for the chest.

FEMALE TORSOS

Check the proportions and size, and follow the instructions for the male torso to create a trapezoid shape. The female form is more curvaceous, with a more defined waist and rounded shoulders. Mark the base of the bust, about a third of the way down. Accentuate the waist and hips.

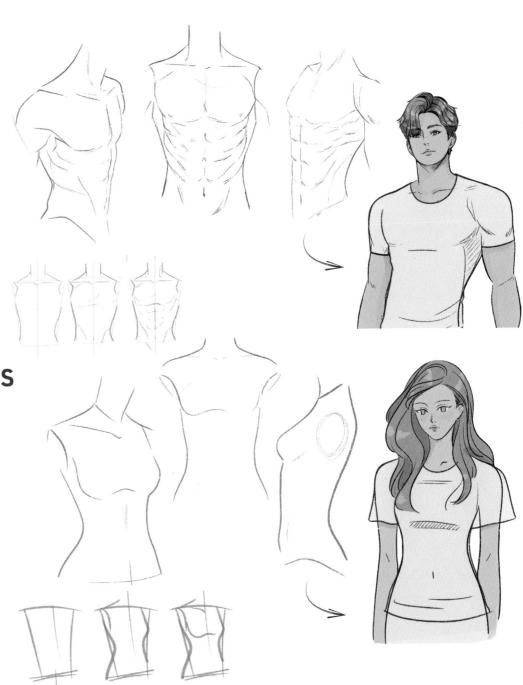

GENERAL PROPORTIONS

A helpful trick for judging the proportions used in figure drawing is to divide the body into sections, based on head size. In general, the length of the head fits about 7.5 times into the height of the body of an average adult. Use the head unit as a measurement guide to check the scale of other body parts.

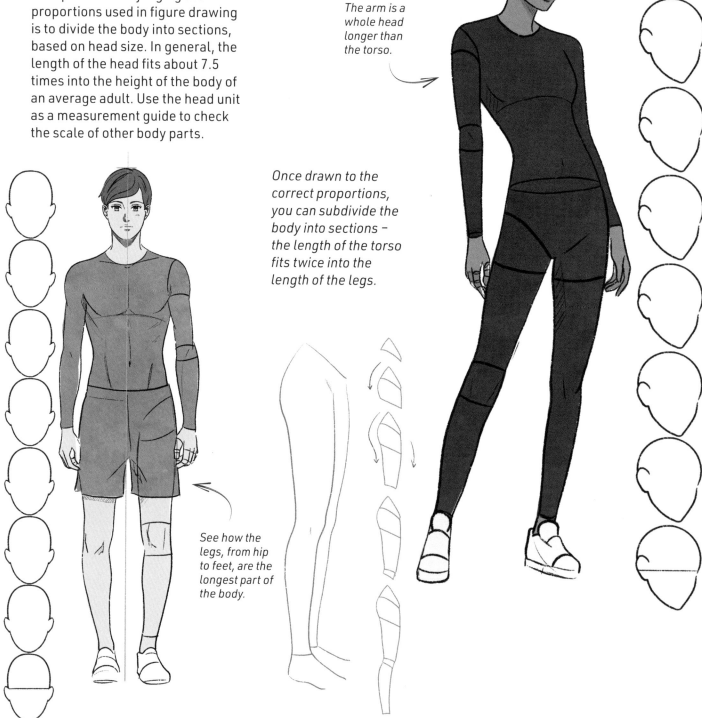

The arm is a whole head longer than the torso.

Once drawn to the correct proportions, you can subdivide the body into sections – the length of the torso fits twice into the length of the legs.

See how the legs, from hip to feet, are the longest part of the body.

GETTING TO KNOW FABRIC

Follow the tips below to help you draw clothes with convincing folds, creases and gathers. The type of fabric will dictate the thickness and fluidity of the folds, so look closely at the difference between wool, cotton and silk, for example, and make notes in your sketchbook, observing clothes in real life and from other sources, like books, magazines, web pages and, of course, other manga artists.

Think about the effect of the pose on the fabric. Creases occur where arms or legs are bent, fabric tends to pull across the chest, and skirt hems will fold and ripple with movement.

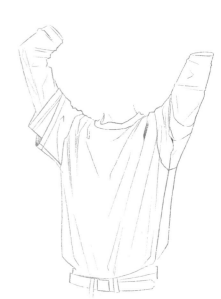

For folds and pleats, add shading to suggest the depth of the fold.

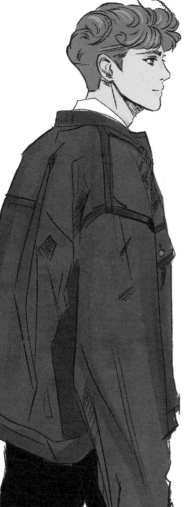

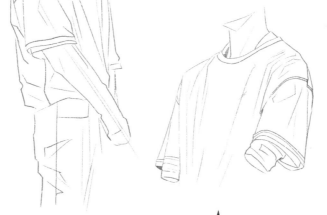

Use precise lines for crisp fabrics, like cotton. Look for areas of tension where fabric is stretched and reflect them in lines that follow the direction of the folds.

1.

STREETWEAR

This is my favourite fashion style to draw. From oversized pieces to a pair of trainers, there are so many garments that you can mix and match to give your character street style.

FUN
CASUAL
SIMPLE
OVERSIZED
LOOSE-FITTING

INDIVIDUALISM
TRAINERS
STATEMENT PIECES
URBAN

LOGOS
LIMITED EDITIONS

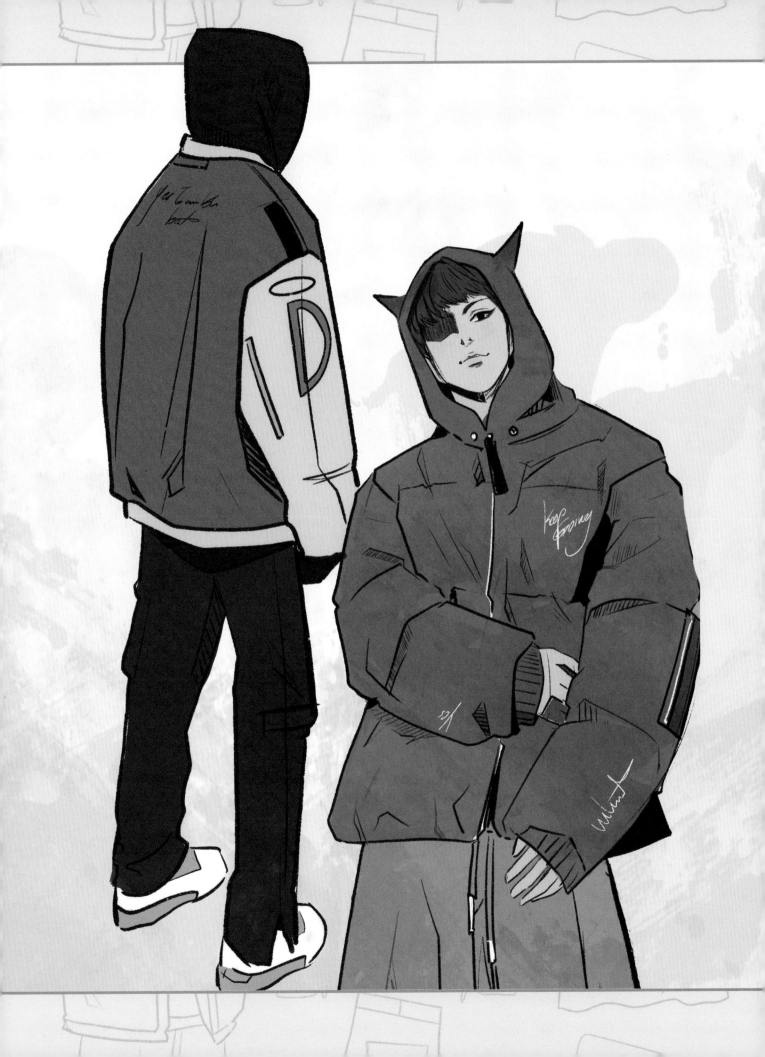

TRACKSUIT

This outfit is simple yet reflects a no-nonsense attitude. The baggy track pants and tight-fitting, zipped top are practical and understated, and the oversized jacket takes this from casual to street in an instant. I gave the character a powerful pose, to convey her confident vibes and strong personality.

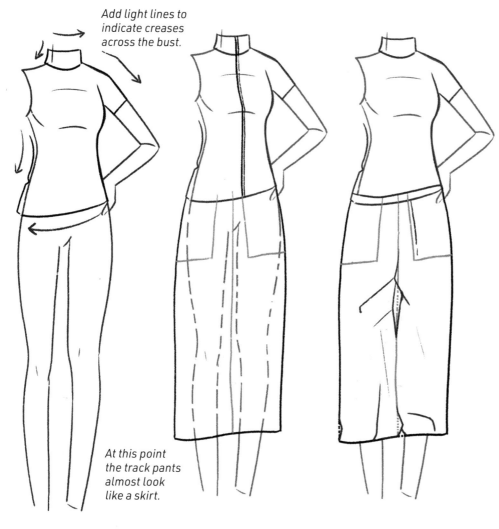

Add light lines to indicate creases across the bust.

At this point the track pants almost look like a skirt.

Use the folds of the fabric at this point to add some shape and style to this feature.

Hem fold detail

1 Start with a simplified drawing of the pose. Add lines to indicate the tight-fitting top – the sleeves, neckline and hemline – following the shape of the body.

2 Now draw in the baggy track pants. Draw their outline, using the proportions of the body guide beneath and the natural curves to judge the width from the hips downwards.

3 Next, add details to the track pants, using lines and shading to describe the folds. Track pants are generally made from quite thick fabric, so try to suggest this in the way the folds follow the body.

For a streetwear vibe, I gave the track pants large pockets and showcased the draw-strings at the waist.

THE OVERSIZED JACKET

Layering clothes makes an outfit much cooler. Think about how the added layers relate to the body; here, the pose of the arms creates space and depth, which you need to reflect in the folds and shape of the jacket.

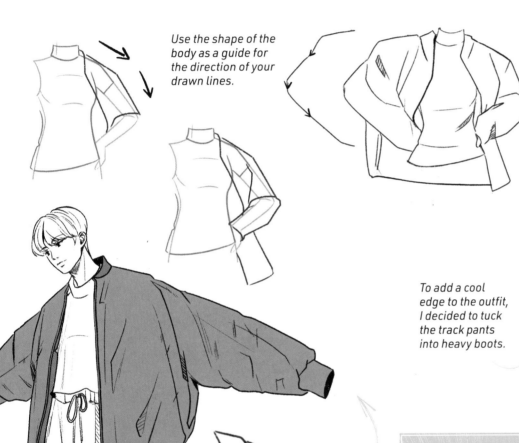

Use the shape of the body as a guide for the direction of your drawn lines.

To add a cool edge to the outfit, I decided to tuck the track pants into heavy boots.

An oversized jacket means hands are hidden in cuffs, so you just need to break the sleeve shape down into simple outlines.

ACCESSORIES

To complete the look, I drew a bunch of accessories, including a beanie hat, ring and chunky boots. Your choice of finishing details will reflect the personality of your manga character, and be instantly recognisable to fashion afficionados! We'll look at accessories in more detail on pages 21 and 23–25.

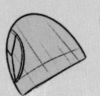

PUFFER JACKET

Often combined with a hoodie, the puffer jacket is an essential streetwear item to finish any outfit. The trick to drawing it realistically is to observe how the quilted sections add 'puff' to the puffer.

1 For a side view, draw the profile of the jacket's outline, using the shape of the body as a guide.

2 Start with a simplified outline, with the sleeve and collar in place, to use as a guideline for building details. Note the bulkiness of the form and the way the jacket hangs away from the waist at the front and back.

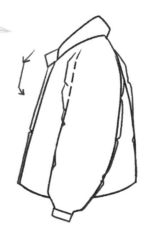

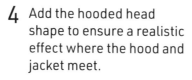

Follow the angle of the chest and back in the jacket's profile.

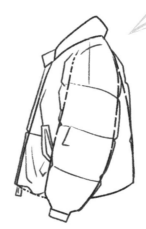

3 The puffer jacket is a quilted design with sections that are 'puffy' between the stitching. Note that the textile doesn't drape much.

4 Add the hooded head shape to ensure a realistic effect where the hood and jacket meet.

5 Build more details, such as lines to indicate stiff folds, which will help to suggest the bulk of the garment.

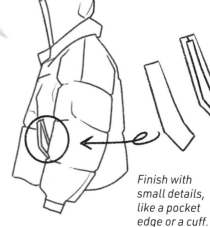

Finish with small details, like a pocket edge or a cuff.

JOGGERS

Another standard streetwear item, joggers or sweatpants are a unisex garment that are worn year-round. They are often made of soft fabric with a drawstring waist and elasticated ankles.

1 Start with a simplified outline that follows the body, using the width of the waist and hips to create a roughly rectangular shape, narrowing towards the ankle.

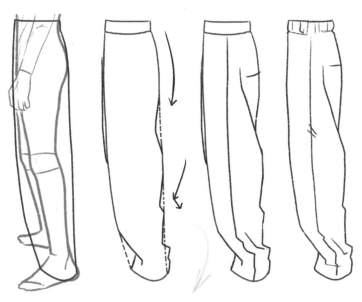

Mirror the shape and angle of the leg to achieve a natural flow.

2 Add the seamline down the leg, noting how it bends and distorts as the joggers crease at the ankles.

3 Draw folds and creases to suggest the soft fabric, with rounded shapes where the joggers bunch up at the waist or hems.

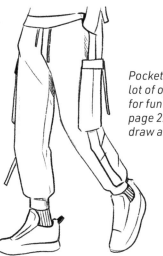

Pockets can add a lot of opportunties for fun poses. See page 22 for how to draw a pocket.

MANGA ART SECRET
The secret of great streetwear is to mix things up – pair sweatpants with an oversized bomber jacket or tuck them into chunky boots. Your character can pull it off in style!

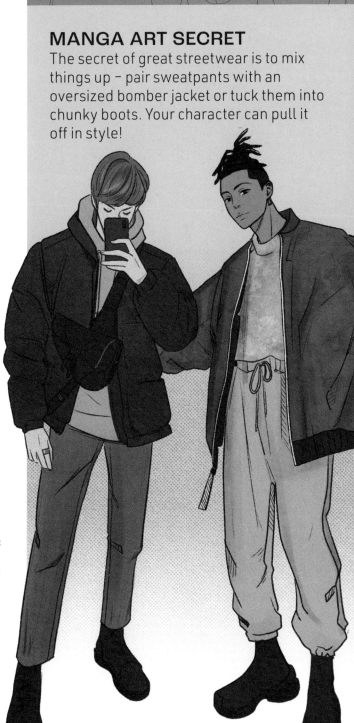

SHORT-SLEEVED SHIRTS

A streetwear staple, the short-sleeved shirt is often a boxy, oversized shape that disguises the body. Look closely at how the shirt changes shape depending on the orientation of the pose: try this exercise in drawing from different angles and you'll soon have it nailed.

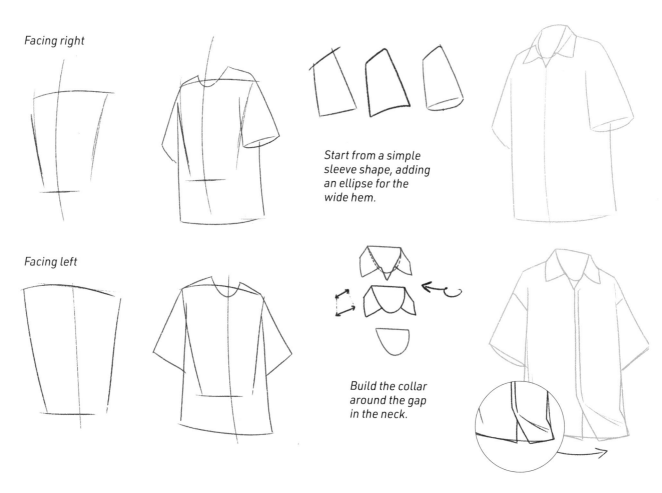

Facing right

Start from a simple sleeve shape, adding an ellipse for the wide hem.

Facing left

Build the collar around the gap in the neck.

1 Start by assessing the orientation of the pose; is it face on, profile, angled to the left or right, facing down or back? Add guidelines to indicate the chest and shoulders, in order to help keep this angle in mind.

2 Next, draw a simplified outline of the overall shape – look for general geometric shapes, such as a rectangle for the body and triangular sleeves. Use the width of the shoulders and their angle to guide the sizing of the shirt.

3 Once the form of the shirt is established, you can add details such as the collar and the button placket. To draw collars, start by defining the open space around the neck (the neck seam), then add the simplified collar shapes on each side.

4 Now work on the shirt shape, always thinking about how the drape of the fabric follows the angle of the pose. Creases and folds may be sharp if the fabric is crisp or stiff.

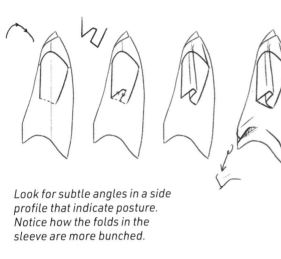

Look for subtle angles in a side profile that indicate posture. Notice how the folds in the sleeve are more bunched.

Here is a visualisation of how the shirts that we drew will look in a finished outfit. Combined with the full-length figure, dressed in shorts and trainers, the short-sleeved shirt gives the whole outfit an instantly recognisable streetwear style.

ACCESSORIES

A branded pair of trainers goes with anything. From skate shoes to high tops, there are so many styles to choose from. To draw them is simple: sketch the whole foot and create a basic silhouette of the trainer, add the tongue and laces, and finally the instantly recognisable brand logo.

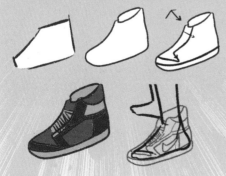

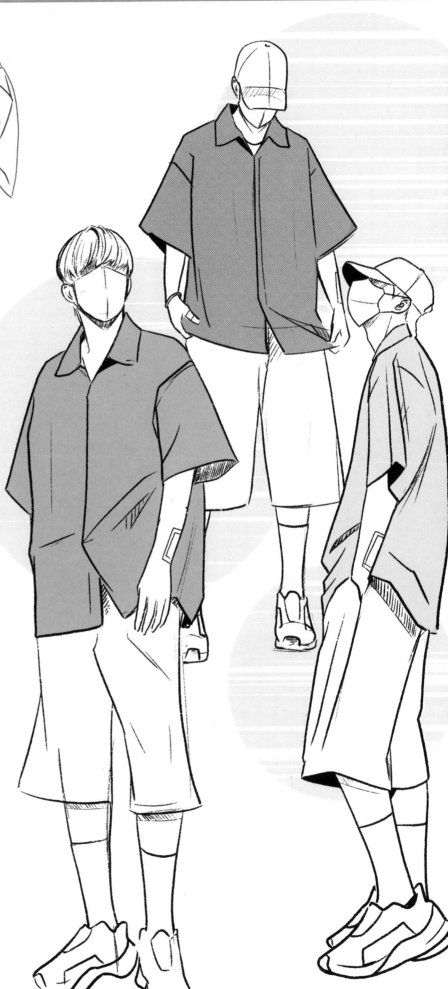

CARGO TROUSERS

Long and baggy is the hallmark for streetwear trousers but the addition of a pocket, or several, will really give your manga character credibility and somewhere to stuff their hands to complete their pose.

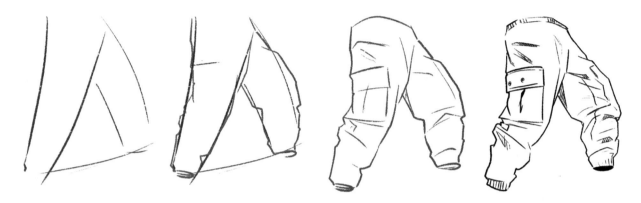

1 Add the basic outline of a pocket, using simple lines to mark an inseam pocket or the position of an outer patch pocket.

2 Now you can add the details. The more details you include, the more complex your drawing will feel. Sketch in pocket flaps, buttons or press studs, straps, buckles and zips.

3 In addition to the pocket details, remember to include folds and creases in the fabric. Think about the anatomy beneath the trousers, with creases around bent knees or folds at gathered ankle cuffs.

THE POCKET

Drawing a pocket is a case of constructing it layer by layer. Think about the different elements as simple shapes, starting with the base layer of the patch pocket, adding a flap or any stitched seams, with extra layers of straps or buckles on top.

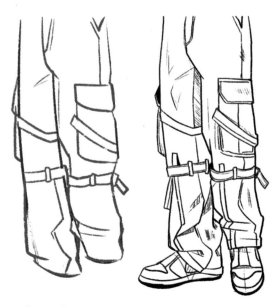

Mix and match straps, buckles and pockets.

BASEBALL CAP

A baseball cap can define your character's overall look. A rigid visor and panel construction makes them distinguishable from other hats; choose from fitted, snapback, flexfit and trucker styles, following the tips below for getting a realistic shape and 'fit'.

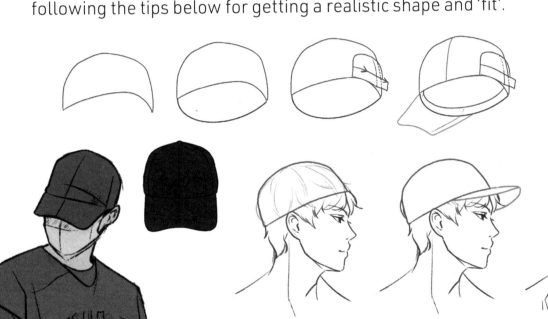

1 Start by drawing the main part of the hat as a simple half circle, matching the size to the top of the head.

2 Add the peak, or visor, including the underside, which helps to communicate the angle of the person's head.

3 Now add some style with a few extra details: use double rows of stitching for the panels on the crown of the cap and a strap to adjust the fit at the back.

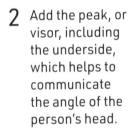

MANGA ART SECRET
Using a reference, like a photograph or illustration, is a great way to practise drawing tricky subjects like clothes and will help you on your drawing journey.

THE BUCKET HAT

Hats can change the whole look of an outfit, adding style and personality to the character. There are so many shapes and styles to choose from (see page 23 for baseball caps), some of which are more casual than others, so when drawing streetwear, carefully match the hat to the clothes to complement the overall look.

1 Start by drawing a trapezoid shape.

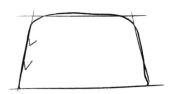

2 Next, modify the shape by smoothing the corners with a gentle curve.

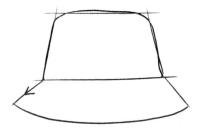

3 Now add the second shape of the brim to give the overall shape of the hat. Drawing from the top to the bottom makes the lines smoother overall.

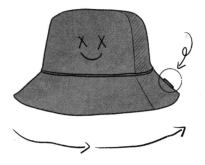

4 Refine the shape, adding slight curvatures to the brim and seam to give a natural look, avoiding straight lines.

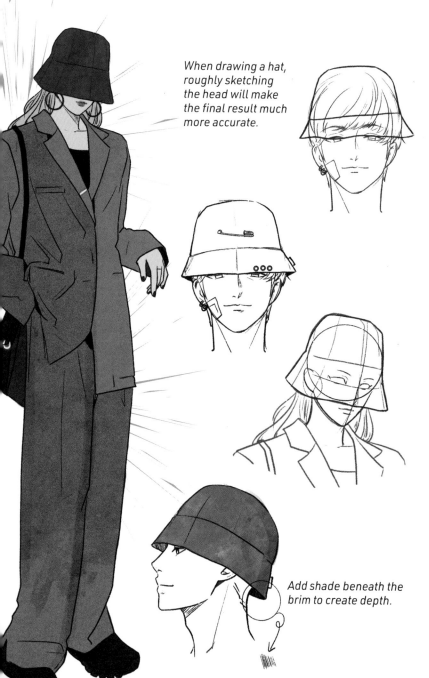

When drawing a hat, roughly sketching the head will make the final result much more accurate.

Add shade beneath the brim to create depth.

THE BEANIE

The fashionable beanie is relatively simple to draw and can greatly enhance a character's street cred. Two important things to consider are to match the size of the hat to the head, and to use the lines of ribbing to help describe the head shape beneath.

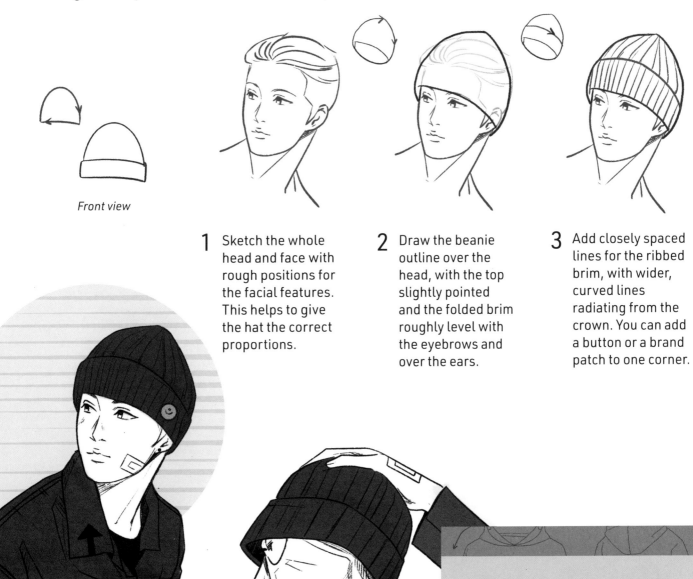

Front view

1 Sketch the whole head and face with rough positions for the facial features. This helps to give the hat the correct proportions.

2 Draw the beanie outline over the head, with the top slightly pointed and the folded brim roughly level with the eyebrows and over the ears.

3 Add closely spaced lines for the ribbed brim, with wider, curved lines radiating from the crown. You can add a button or a brand patch to one corner.

MANGA ART SECRET
The trick when drawing hats, whether it's a beanie or a bucket hat, is to take the shape of the head beneath as your starting point.

CUSTOMISED JACKETS

It can be great fun to draw jackets that reflect something of your character's personality. Add badges, logos and typography to the front, back and sleeves. Play around with designs, creating different combinations that add to the overall look for your character.

Take a basic varsity or baseball jacket (right) and get creative. You have control over the design, so customise with simple lettering, using the front panels for bold effects. Remember to follow the flow of the fabric and incorporate any creases into your design.

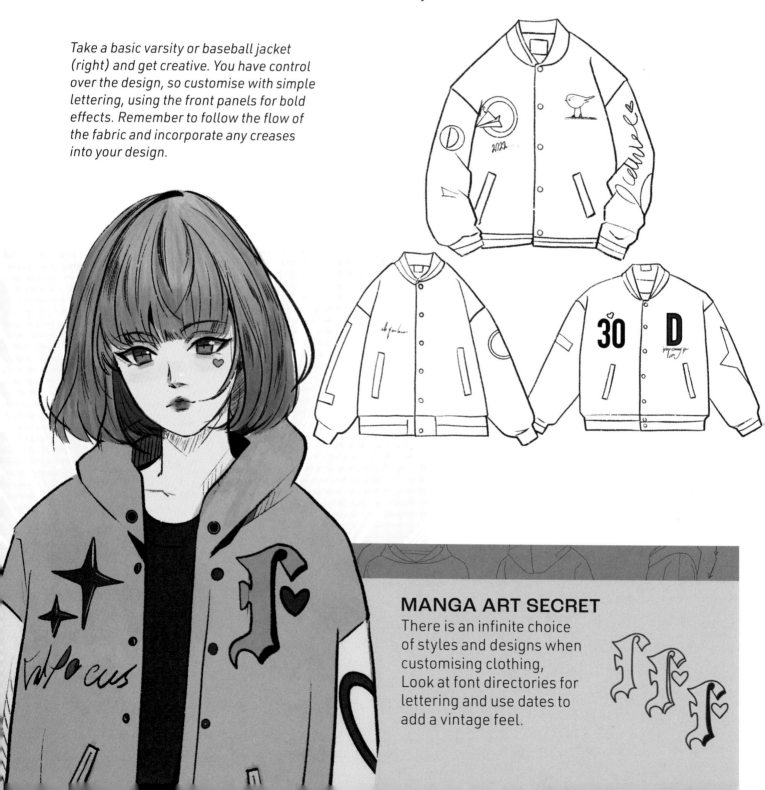

MANGA ART SECRET

There is an infinite choice of styles and designs when customising clothing, Look at font directories for lettering and use dates to add a vintage feel.

1 Start with a simplified outline of the pose, including the head. The shoulders and neck, and tilt of the head, all help to establish a natural feel to the dimensions of the jacket.

2 Sketch in the general outline of the jacket, keeping a simple shape that maps the sleeves, neck and hem, so that the proportions are correct in relation to the body and arms beneath. Remember that the jacket is quite bulky, so allow some 'room' outside the arms and torso.

3 Now you can start to add details. The sleeve seams on this jacket style are dropped, or off the shoulder, and it often features a ribbed hem at the base and around the cuffs. The neck is also ribbed on a bomber jacket, but I have customised mine to include a hood.

4 At this stage, the jacket can be embellished with badges and designs that reflect your manga character's personality.

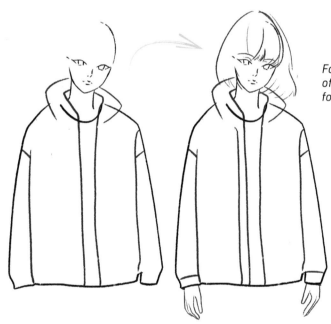

Follow the the shape of the neckline for the folded hood.

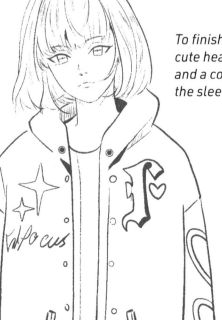

To finish, I have added a cute heart to the design and a couple of hearts on the sleeve.

I have added the initial for my character's name to the back of the jacket. I've chosen an artistic font and, to make it look more interesting, I have added some shadows to give it a 3D effect that will make it look more prominent.

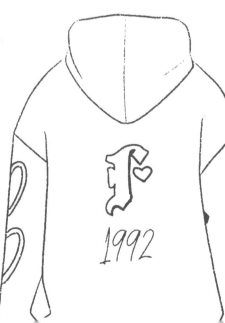

HOODIES

A hoodie is a go-to garment for virtually any fashion style. It is generally made from comfortable fabric and the hood adds not only a cool vibe, but also offers protection from the weather. For manga, add some interest and variety with graphics to the front or back, and pair with anything from jeans to shorts.

HOODS

Drawing a hood might seem a little challenging at first because of the different shapes that it creates when seen from one angle to another, and whether the hood is up or down. Practise by using a reference, either from photographs or your own hoodie. Start with the general outline and then add the neck opening, keeping it in proportion to the body.

Add some descriptive lines for the layers of folds and any stitched seams.

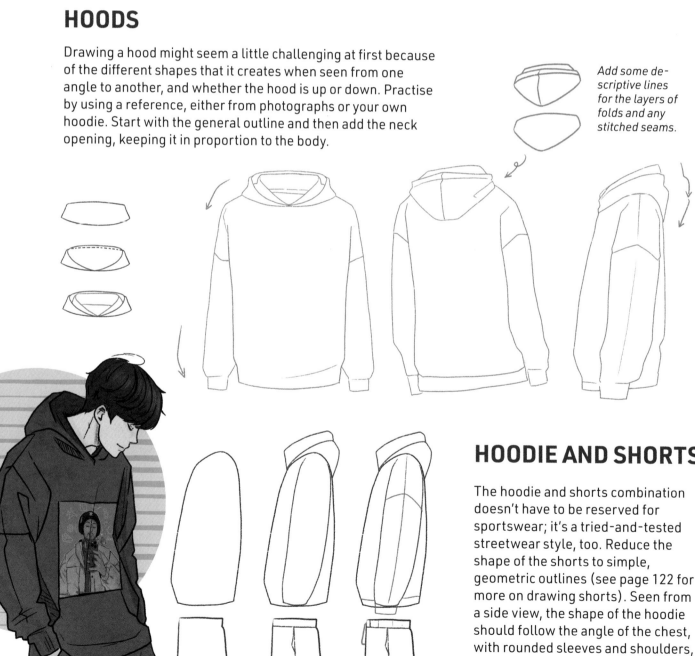

HOODIE AND SHORTS

The hoodie and shorts combination doesn't have to be reserved for sportswear; it's a tried-and-tested streetwear style, too. Reduce the shape of the shorts to simple, geometric outlines (see page 122 for more on drawing shorts). Seen from a side view, the shape of the hoodie should follow the angle of the chest, with rounded sleeves and shoulders, to suggest a thick fabric.

THE BASIC HOODIE

A hoodie is simply a thicker version of a long-sleeved tee (see page 38), with a loose fit that keeps its own shape rather than following the torso. Once the basic sweatshirt shape is drawn, add the outline of the hood opening, taking care to match the proportions to the neck opening. Seen from the front, the opening has a rounded diamond shape. Now you can add design details, such as a pouch pocket, drawstrings and a ribbed hem and cuffs. Take your basic hoodie to street level with graphics or logos.

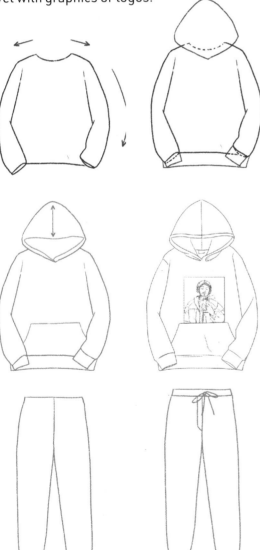

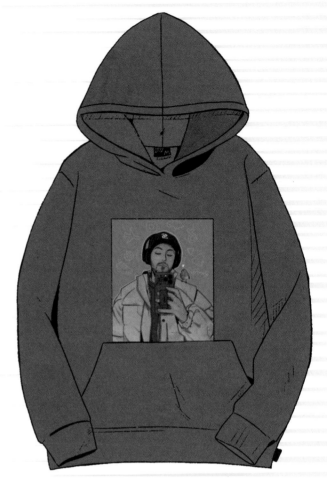

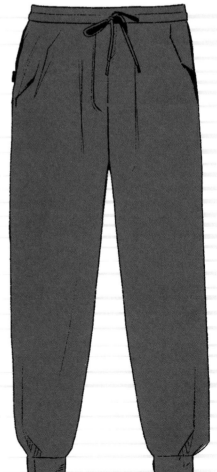

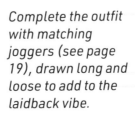

Complete the outfit with matching joggers (see page 19), drawn long and loose to add to the laidback vibe.

Draw a jacket shape as a base to customise with badges, following the instructions on pages 26–27. Use dates, initials or motifs that suit your manga character.

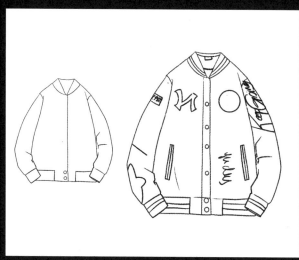

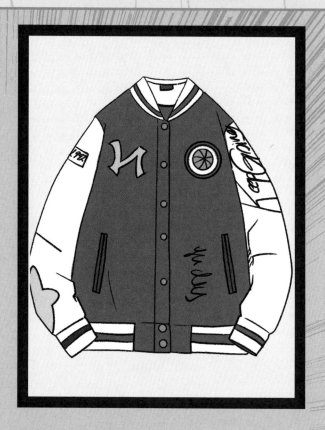

EXERCISE ROUND-UP

Streetwear is all about understatement and oversized clothes. Follow these quick exercises to bring together jackets and trousers, finishing with that essential street accessory, a hat.

Use the exercise on page 22 to draw a pair of baggy trousers that will complete any streetwear outfit.

Have fun experimenting with drawing different hat shapes. Start with a bucket hat using the exercise on page 24 as a guide, adapting it to your own designs.

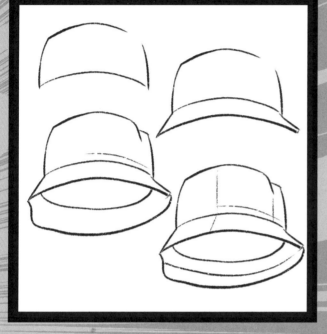

Layering is key to streetwear. Practise by drawing a tight T-shirt and add a simple shirt on top, following the instructions on page 20 for short-sleeved shirts.

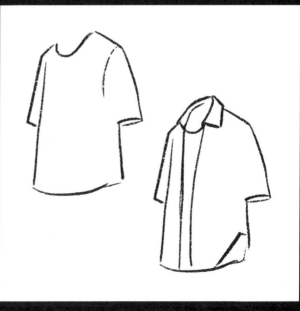

2.

CASUAL CLOTHING

Casual clothes have a simplicity and universality that sets them apart from other clothing trends. An outfit consisting of a pair of jeans, a T-shirt and sneakers sums up this style and will make your character looked relaxed and chilled.

PRACTICAL
COMFORTABLE
MINIMAL
EASY GOING
UNIVERSAL

CHILLED
RELAXED
VERSATILE
MIX AND MATCH
EVERY DAY

LAID BACK
SIMPLE

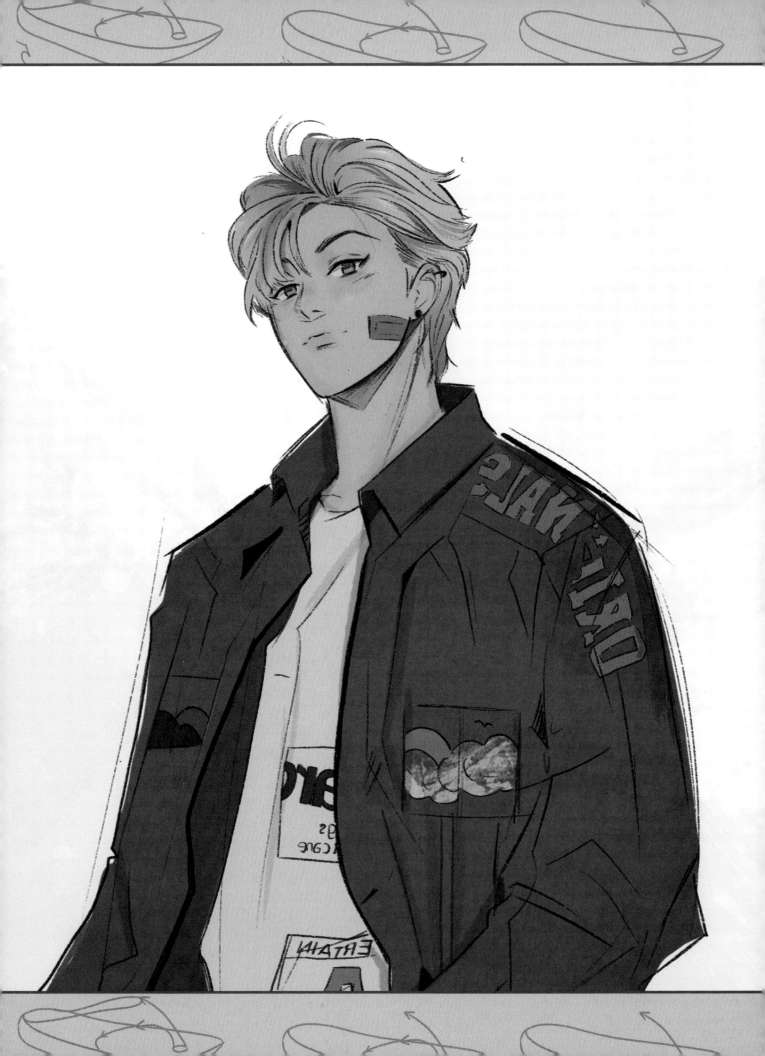

T-SHIRTS

T-shirts define casual style. They are an item of clothing that we are all familiar with, and something we usually wear on a daily basis, whether patterned or plain, tight or loose. They tend to be simple to draw and work with various outfits, either as a base layer or tucked into jeans for a classic look.

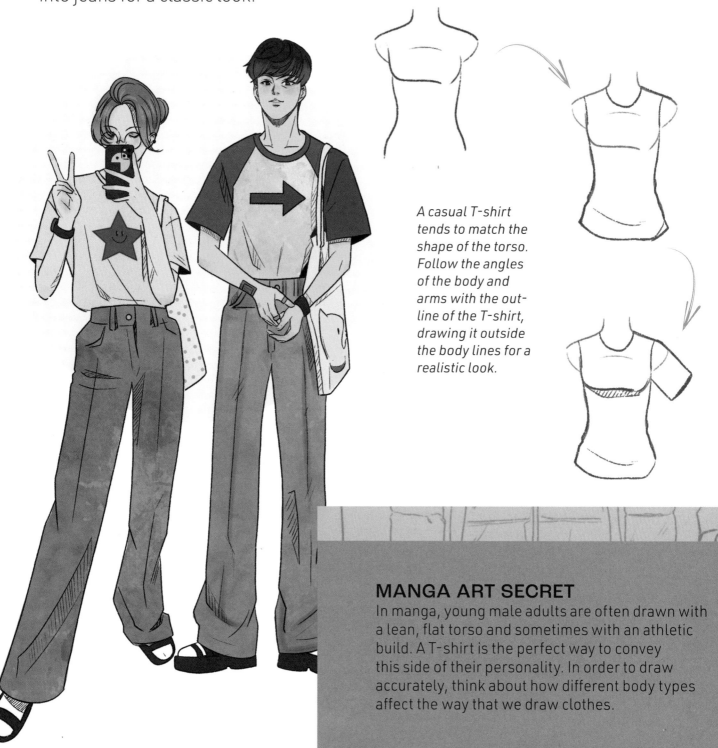

A casual T-shirt tends to match the shape of the torso. Follow the angles of the body and arms with the outline of the T-shirt, drawing it outside the body lines for a realistic look.

MANGA ART SECRET

In manga, young male adults are often drawn with a lean, flat torso and sometimes with an athletic build. A T-shirt is the perfect way to convey this side of their personality. In order to draw accurately, think about how different body types affect the way that we draw clothes.

1 Start by breaking down the shape of the T-shirt into simple, geometric shapes for the body and sleeves.

2 Add the neckline and an angle to the hem to give a more natural, rounded shape.

3 A few lines around the armpits and hem are all that are needed to suggest creases in the fabric.

4 The same principles apply when drawing the back of a T-shirt – it's simple and easy to wear, and to draw!

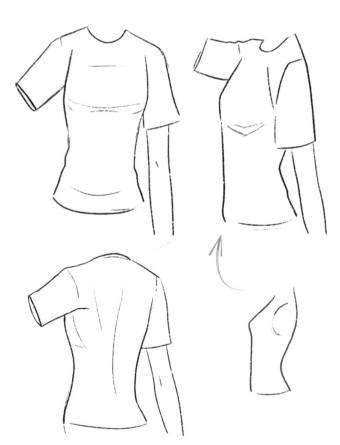

The T-shirt is a loose-fit design, so you only need a rough sketch of the body to start with to give an idea of the shoulders and arm positions, and the body proportions.

ACCESSORIES

You can build a whole outfit around a T-shirt. Here are a few items that I like to add to my drawings to give a fun and fashionable vibe when combined with a basic tee.

CASUAL FOOTWEAR

Comfort plays a huge role when it comes to casual clothing style and some of the most fashionable items are popular based solely on how comfortable they are! Slip-on shoes are the ultimate in easy-to-wear: include any variation on flip-flops, mules, sliders and clogs, and your character will instantly have a cool and laid-back air.

FLIP-FLOPS

1 If your character is sporting a pair of flip-flops it means that most of their foot will be visible, so you need to practise drawing feet accurately first. Start with a flat, standing foot to use as reference.

2 Using the shape of the foot, draw the outline of the footprint, making sure that you have the right orientation and that the heel and sole appear to be in contact with the ground.

3 Now add the sole of the flip-flop, adding depth along the length and narrowing at the toes to accentuate the shoe's shape.

4 Add the straps, starting with the toe thong. Add height to the thong and position the side bars at the correct placement to curve around the foot.

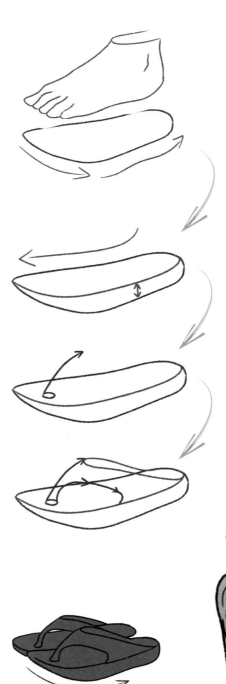

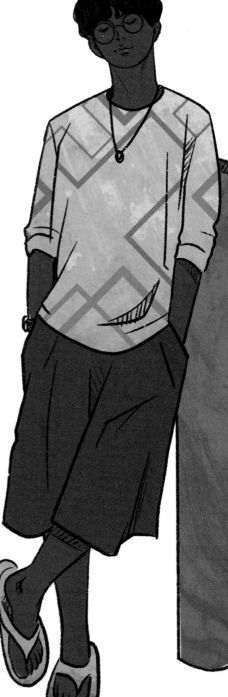

Flip-flops add the perfect finishing touch to this laid-back look combined with baggy shorts and a casual pose.

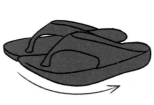

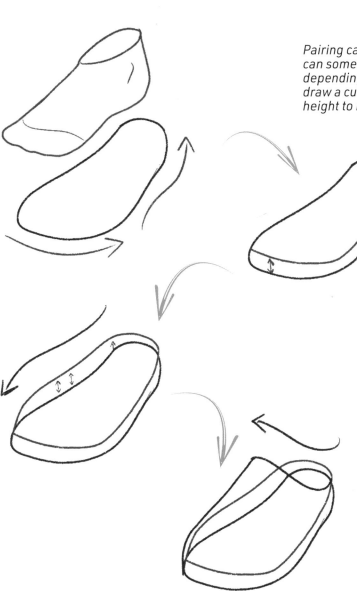

Pairing casual footwear with socks can sometimes be fashionable depending on the shoe. Simply draw a curved line on the leg, at the height to match the sock style.

THE MULE

A closed-toe – found in mules, clogs and slippers – is relatively simple to draw as you don't need to worry about adding toes! A staple of casual wear, the comfy mule is a unisex item that can be slipped on with trousers, jeans, shorts and skirts. Follow the same principles as for drawing a flip-flop or slider, starting with the footprint that matches the position of the feet and adding a sole and upper that leaves the ankle bare.

SLIDERS

Sliders are slightly easier to draw than flip-flops as you only need to add a solid band across the top of the foot. Always start with the position and orientation of the feet first, and use the footprint to guide the placement of the shoe's sole. Don't forget to add the toes!

MANGA ART SECRET

When drawing a manga character, you can build their individual style in subtle ways – for example, adding chunky soles to their footwear will give them some extra height and a bit of street cred, too.

LONG-SLEEVED T-SHIRTS

A casual look should appear effortless and the long-sleeved T-shirt fills this brief perfectly. Often made in soft fabrics with a loose, comfortable fit that stretches as you move, this top works on its own or layered under jackets of all shapes and sizes.

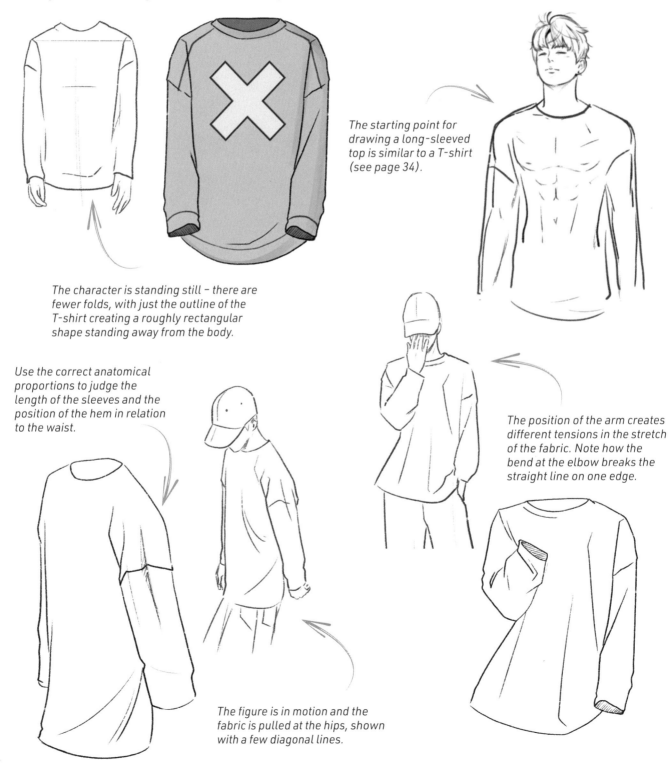

The starting point for drawing a long-sleeved top is similar to a T-shirt (see page 34).

The character is standing still – there are fewer folds, with just the outline of the T-shirt creating a roughly rectangular shape standing away from the body.

Use the correct anatomical proportions to judge the length of the sleeves and the position of the hem in relation to the waist.

The position of the arm creates different tensions in the stretch of the fabric. Note how the bend at the elbow breaks the straight line on one edge.

The figure is in motion and the fabric is pulled at the hips, shown with a few diagonal lines.

Most long-sleeved tops have a similar design of a round neck with stitched cuffs and hems. The sleeve seams may have a drop shoulder or be inset if the sleeves are a contrasting colour. These small details are all you need to turn a simple outline into a realistic item of clothing.

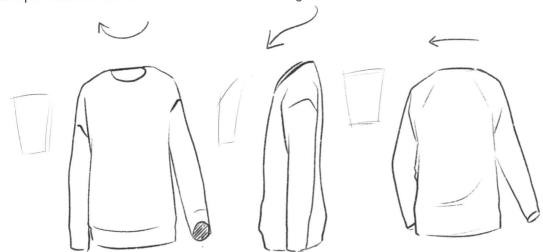

The neck opening differs in each view: rounded when seen from the front; an angled slit when seen from the side; and an almost horizontal line when viewed from the back.

Add some depth to the neckband and some ribbed, elasticated cuffs to turn your long-sleeved T-shirt into a crewneck jumper.

Sketch a rough outline of the body and the pose. Use these guidelines to help with the general fit and shape of the top – the tighter the fit, the more the body affects the fabric and the more detailed the drawing.

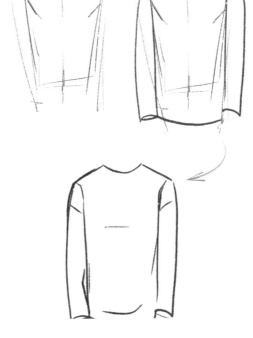

MANGA ART SECRET

Observing how a pose affects clothing in real life will help you to make your drawings even more professional – look at clothing websites, magazines, photographs, adverts and other manga illustrations for inspiration.

Add creases where the fabric pulls across the chest.

TIGHT-FITTING T-SHIRTS

Although casual style often equates to more relaxed fit garments, tight-fitting clothing is just as popular. For comfort, workout leggings, crop tops and tank tops take their cue from materials designed for sport and ease of movement. Skinny jeans or a pencil skirt paired with a tight T-shirt also give a fashionable edge to everyday wear.

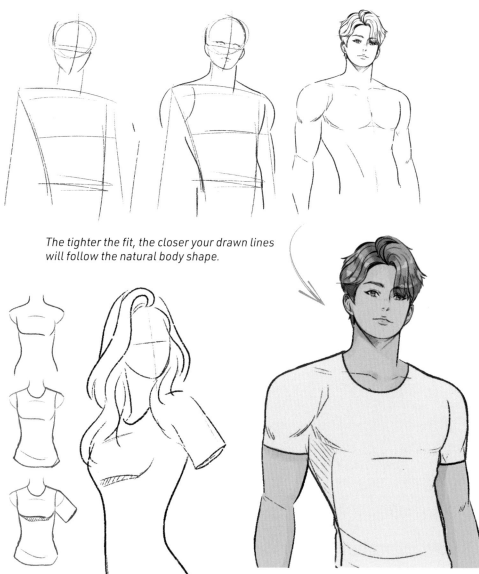

The tighter the fit, the closer your drawn lines will follow the natural body shape.

1 Simplify the pose into general outlines for the head and torso. My character has an athletic build, so the shoulders and chest are wide and the waist is comparatively narrow.

2 Begin adding the outer lines, indicating where the waist comes in. Add small curves for the shoulder muscle and also the biceps.

3 Sketch in the definition of the arm and chest muscles, with light lines indicating outlines around the biceps and pecs. These lines will add a realistic look to the T-shirt when drawn.

4 Finish sketching the body. To finish the T-shirt, add a neckline and the sleeves. Use the curve of the bicep as the end of the sleeve to achieve a close fit.

For a girl's style, start with the torso, adding an outline of a crop top or bra to help guide where the T-shirt fabric will pull and crease.

TRAINERS

A staple of any casual or street style, trainers are the finishing touch to any outfit. Based on a simple shape, you can embellish trainers with straps, flashes, logos, inserts, mesh, laces – anything goes!

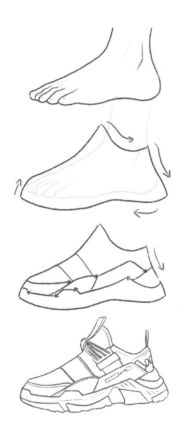

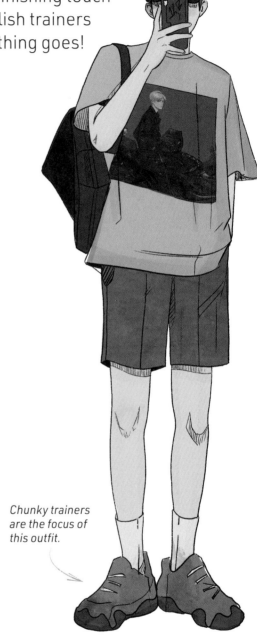

1 Sketch the position of the foot first – a side profile is the simplest view to start drawing.

2 Add the trainer's outline following the foot, but extending the heel out slightly and raising the tongue over the ankle.

3 Trainers often have complex uppers, so add each element separately, checking that you are keeping the exterior shape correct.

4 Finish with details on the cushioned sole – you can make this as simple or as detailed as you like.

Chunky trainers are the focus of this outfit.

Practise drawing laces undone for a cool vibe.

From the back you can only see the edge of the toe section.

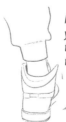

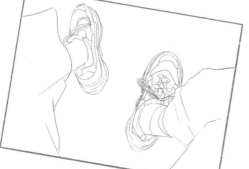

Combine different styles to make your trainers unique.

MANGA ART SECRET
Have fun with designing your own brand of trainers, adding straps or laces, with coloured bands and flashes and cushioned soles.

DENIM

As a fabric, denim is versatile, durable and goes with anything. From jeans to jackets, it is a stand-by for casual style and will give your character a timeless, classic look. Compared to the looser, relaxed fit of other casual clothing types, denim offers different challenges when drawing it – from the rigidity of the material to the small distinguishing details.

DENIM JEANS

Denim jeans have lots of details: pockets, belt loops, contrast stitching on the seamlines, a button and zip, as well as a brand patch on the back. Your jeans can come in traditional shades of blue or you could try different colours. You could also add rips at the knees or thighs for a more edgy look.

Try pairing a tight top with loose-fit jeans or vice versa to create balance.

Loose jeans and a crew-neck jumper create the ideal casual outfit.

Make a feature of pockets, using double stitching in order to emphasise the shape.

To create skinny jeans, just add some details, such as pockets and stitching along the seamlines to the leg shape.

Front view

Side view

DENIM SKIRTS

There are many different skirt designs and shapes. A denim skirt is more restricted as the fabric is stiff, so you won't see as many creases and folds as you might with a silk skirt. Start with the outline of the hips and legs and then add the shape of the skirt, leaving some room around the thighs and calves if you want it to be loose.

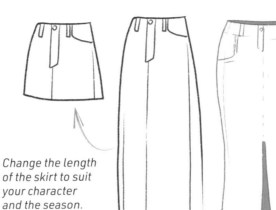

Change the length of the skirt to suit your character and the season.

A pencil skirt simply follows the curves of the hips and outer lines of the legs.

Begin with the pose and an outline of the body. Add the outfit in layers, starting with the top and skirt outline, ensuring that the skirt sits at the waist. Fill in any details, like a pocket, fly and buttons, then carefully erase the underdrawing.

You can always add personality to a denim skirt. Try a pattern or an ombre effect to showcase your character's style.

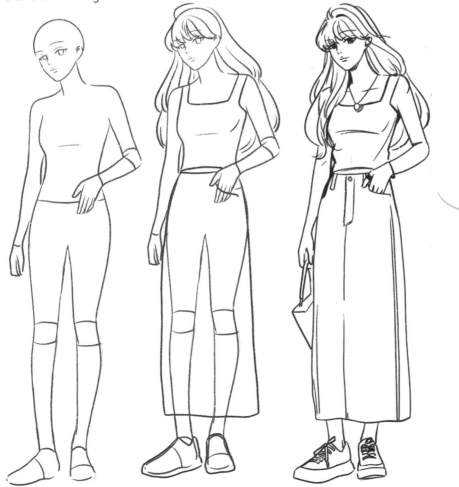

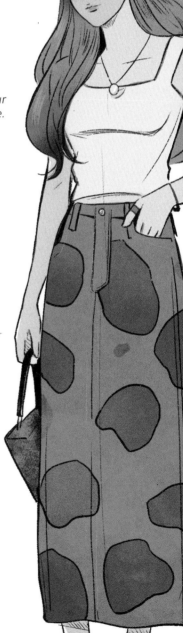

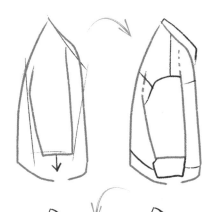

DENIM JACKETS

The thick fabric gives a structured shape to the body and sleeves, and details such as collars and cuffs are also more geometric in their outlines. Look for the fun extras, too, like rivets and metallic buttons, flap pockets and tabs that define a denim jacket style.

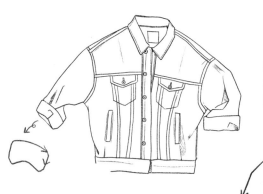

One of the appeals of denim is its durability and this is especially true of the denim jacket.

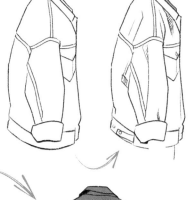

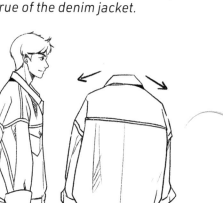

The classic denim jacket is instantly recognisable from its revered collar, chest pockets and wide hem band.

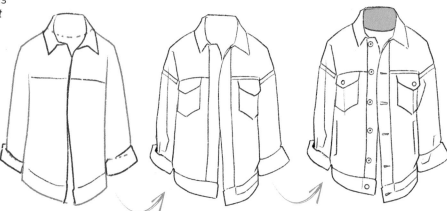

Starting with a simple outline, build a jacket in stages, shaping the sleeves and adding cuffs, before finally adding seams that define each stitched section. Draw lines for folds and creases that give weight to the fabric.

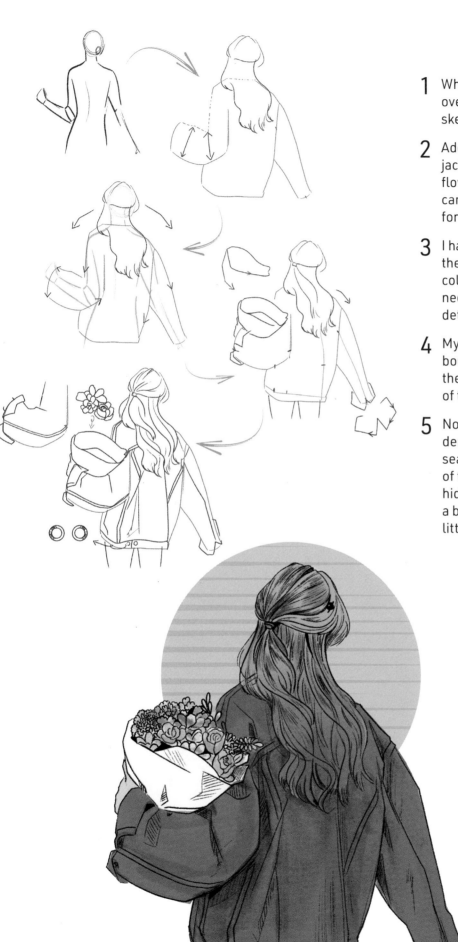

1 Whether you are drawing a slim fit or an oversized jacket, as here, start with a sketch of the body in the basic pose.

2 Add the outline of the main shapes – the jacket body and sleeves – following the flow of the shoulders. If you wish, you can extend the sleeves over the hands for a cute oversized look.

3 I have sketched in the rough position of the hairstyle, which covers the jacket collar, but also flows down the back and needs to be considered when adding details later.

4 My character is holding a flower bouquet, so I have added the outline of the wrapper, fitting it within the curve of the jacket's arm.

5 Now you can add the details that give a denim jacket its character. The stitched seamlines accentuate the thick folds of the fabric and the turned-back cuffs hide the hands. The wide sleeves hint at a borrowed or vintage jacket, adding a little to the character's backstory.

Include details, like metal rivets or buttons, to give that signature denim jacket style.

MANGA ART SECRET

It's easy to give your classic denim jacket a manga twist by simply extending the sleeves so that they cover the hands.

Follow the guidelines on page 38 to practise drawing the simple boxy shape of a long-sleeved tee.

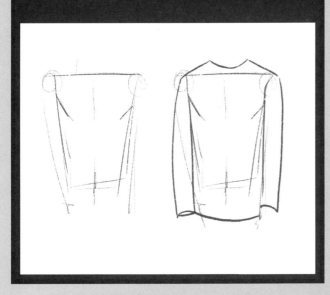

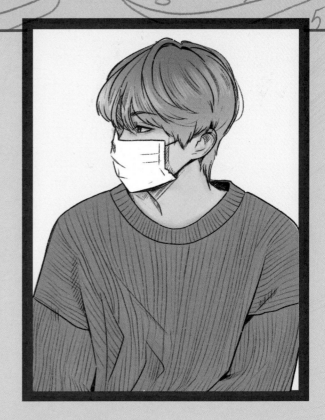

EXERCISE ROUND-UP

Putting a casual outfit together is easy – a tee and trousers layered with a denim jacket and finished with some comfortable footwear. Follow these exercises to practise drawing with the same effortless ease.

Draw denim jackets from every angle, especially with hands in pockets – the ultimate casual pose. See pages 44–45 for more examples.

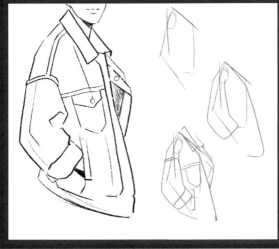

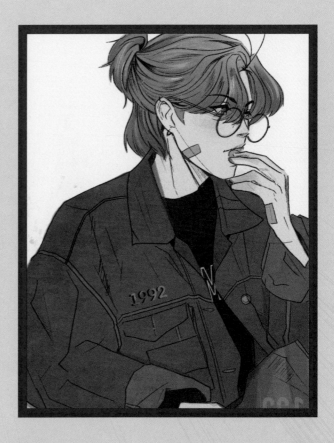

Add a pair of flip-flops to complete an outfit. Start with the feet in the correct pose and follow the instructions on page 36 to build the shoe around them.

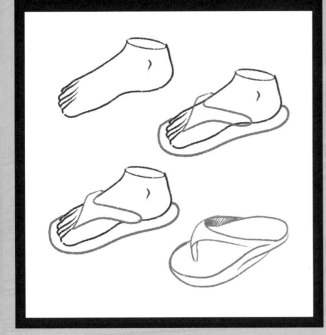

Using a rough sketch of the torso as a guide, practise drawing a classic, loose-fit T-shirt, referring to the steps provided on page 34 for further assistance.

M. UMAIR ALI (@MANGAKAUA983)

Hey y'all, I'm an artist based in the Lone Star State of Texas, USA. My love for manga art grew when I was introduced to manga at my local library and to several classic anime on TV. I started out using paper and pens, but shifted to digital as it was more intuitive for me. I aim to make an appealing combination of prominent line art, with halftones and black ink, and immersive colouring.

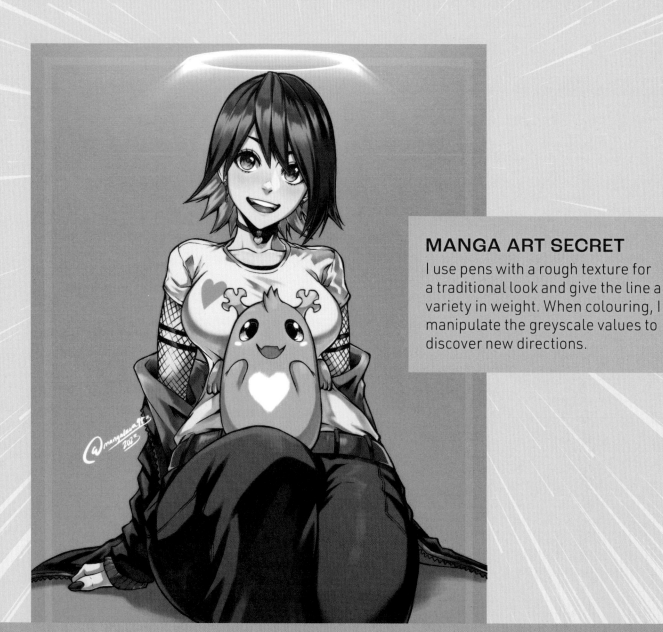

MANGA ART SECRET

I use pens with a rough texture for a traditional look and give the line a variety in weight. When colouring, I manipulate the greyscale values to discover new directions.

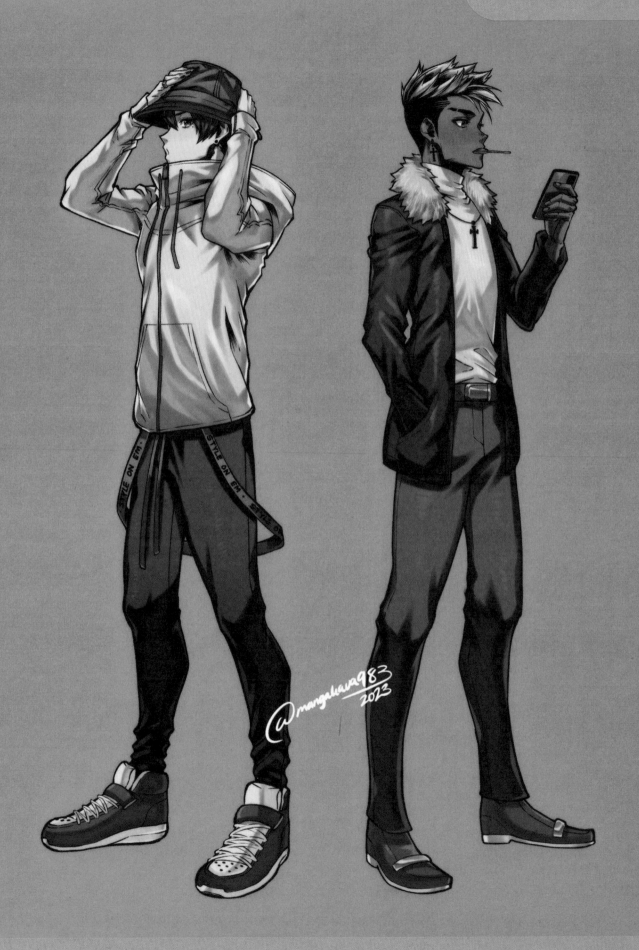

3.

SEASONAL CLOTHING

A new season means a new style. Use your character's clothes to indicate the time of year, creating lots of fun combinations of clothing and accessories to suit the weather, from rain and snow to sunshine and warmth.

COSY

QUILTED

FUR

LAYERS

COATS

INSULATED

TEXTURES

BEACHWEAR

WATERPROOF

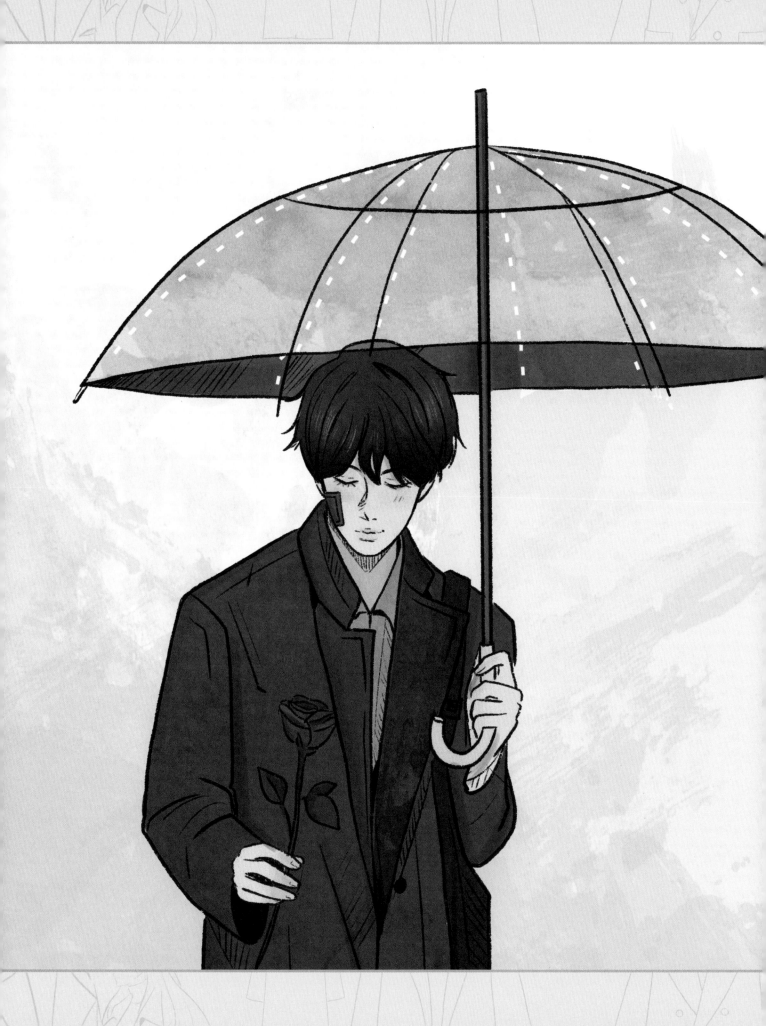

WINTER OUTFITS

Dressing for winter weather means cosy layers and textured fabrics. A puffer jacket with its insulated, quilted design is essential for keeping warm. You can adapt it to suit your character – I've cropped the length here and added a furry collar to upgrade a standard puffer to statement manga style. For more on puffer jackets, see page 18.

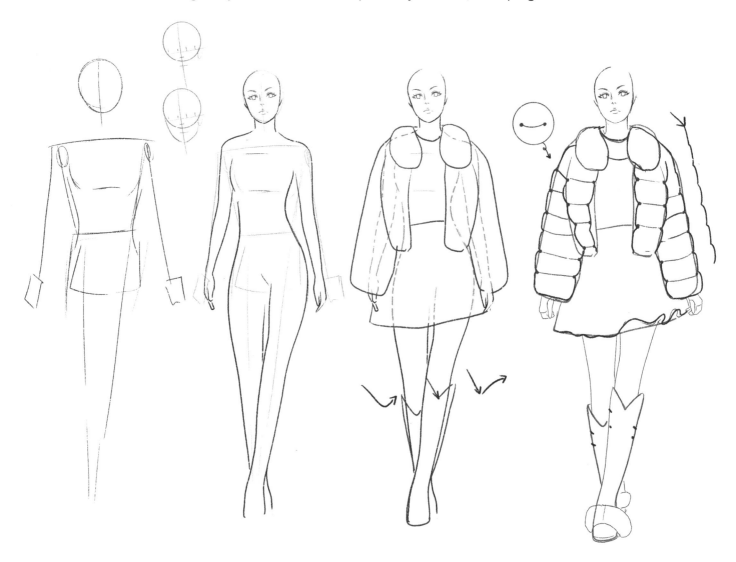

1 Start by breaking the pose down into simplified geometric shapes and establish the proportions of the body (see pages 11–12).

2 Build a natural body shape around your guidelines, to give a realistic base for 'clothing' your manga character.

3 Now add a simplified outline of the outfit. Here, I'm going for a cute winter's day vibe that uses base layers, a skirt and boots, and a puffer jacket as the focal point.

4 Draw rows of stitching that are slightly curved, to divide the jacket into sections and give it a puffed, quilted look.

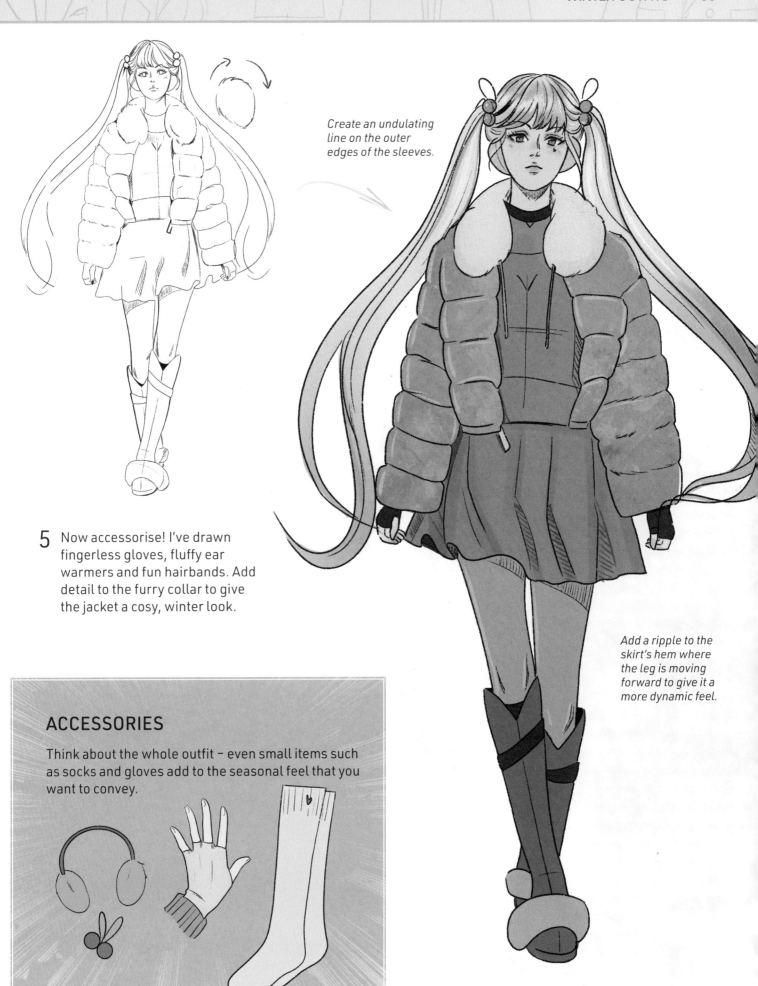

Create an undulating line on the outer edges of the sleeves.

5 Now accessorise! I've drawn fingerless gloves, fluffy ear warmers and fun hairbands. Add detail to the furry collar to give the jacket a cosy, winter look.

Add a ripple to the skirt's hem where the leg is moving forward to give it a more dynamic feel.

ACCESSORIES

Think about the whole outfit – even small items such as socks and gloves add to the seasonal feel that you want to convey.

OVERCOATS

An elegant classic, the long overcoat is a popular choice for keeping warm and dry. Worn by men and women, overcoats can be both formal and casual, and come in a multitude of styles and cuts that are perfect for layering.

DOUBLE-BREASTED OVERCOAT

1 Start by mastering the basic overcoat. Sketch in a simple rectangular guide to indicate the length and width of the coat body.

2 Add the sleeves, checking the length is in proportion to the body and ensuring that they are wide enough for the thickness and weight of the material.

3 Next, add the lapels and collar, keeping the shapes quite angular here to suggest the relative stiffness of the material that they are made from. Finish by adding the details of buttons and pockets.

For a double-breasted version, the coat is buttoned off-centre.

For necklines, simplify the shape of the open neck to begin with and then add the collar around it.

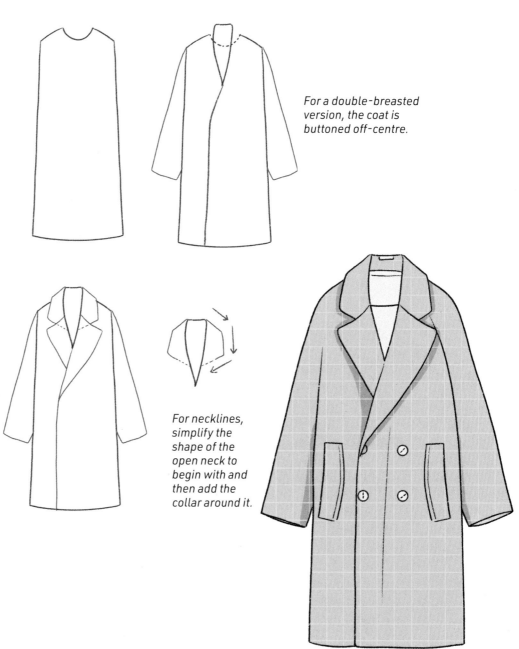

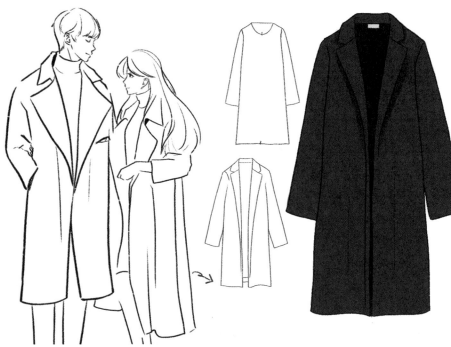

TRENCH COAT

Not all coats are made for winter weather. A suitable coat for spring or autumn, like a trench coat, is made from lighter fabric, and you can indicate this by adding more fluid lines and folds to the drawing and giving the coat a slimmer silhouette with narrower sleeves.

For a manga twist, an overcoat should be large and long, with a simple outline that finishes an outfit to give the character a refined air.

SKIRT COAT

Coats come in many cuts and shapes, and belted or waisted versions are great for emphasising feminine style. This skirted shape has a crossover neckline and form-fitting top matched with a gathered skirt, which is indicated simply with a rippled hem and matching fold lines.

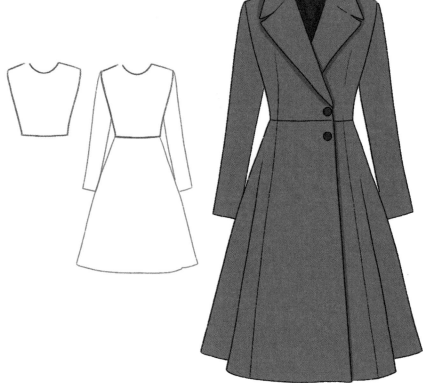

MANGA ART SECRET

As for sleeves, drawing from the top downwards produces smooth lines. You can apply this technique to anything, from clothing to drawing hair. Continue practising and the lines will keep getting smoother, and the results will be even more professional.

WET WEATHER GEAR

Whatever the season, rainy weather is a great opportunity for some fun clothing styles that look cute and call for accessories like Wellington boots and umbrellas, all things you can experiment with and incorporate into an expressive pose.

WELLINGTON BOOTS

The classic Wellington boot is made from rubber and so holds its shape well. The boot can be knee-length or shorter, but generally follows the shape of the calf with a sturdy sole.

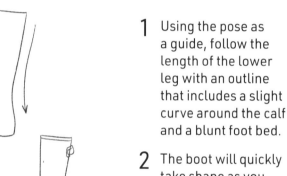

1 Using the pose as a guide, follow the length of the lower leg with an outline that includes a slight curve around the calf and a blunt foot bed.

2 The boot will quickly take shape as you add the details of the rubberised seams on the top of the foot and indicate the thick sole.

3 Add the leg where it emerges from the boot, and fill the top rim with dark shadows on the inside to give it depth.

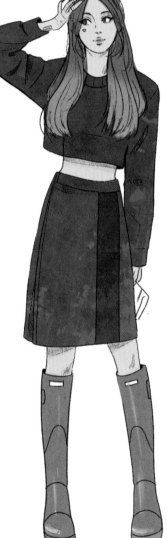

BUCKLES AND STRAPS

A traditional Wellington boot often has a buckled strap on the outer edge. Start with the outer shape of the buckle base. Add the strap on top.

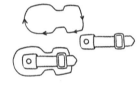

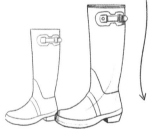

Subtle highlights on the toe caps and down the front of the boot suggest a shiny surface.

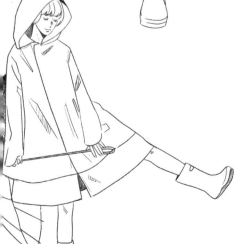

THE PONCHO

A waterproof, hooded cape, the rain poncho is a cute piece of wet weather clothing that instantly adds a bit of fun and timeless style. Hoods are also a great way to frame your character's face.

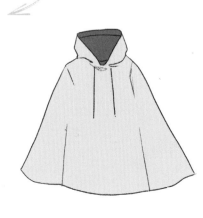

UMBRELLAS

The classic accessory for wet weather, you can have lots of fun with this everyday item – use it to enclose a couple of sweethearts, to add an atmosphere of rainy melancholy, or as an elegant prop when folded away. You can easily adapt the basic shape to a summer parasol or make it transparent.

ROLLED-UP UMBRELLA

A furled, or rolled-up, umbrella is an elegant accessory. Connect the directional lines to the tip of each rib and look closely at how the folds are gathered together at the strap.

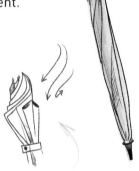

Use shading inside the folds to give depth.

TRANSPARENT UMBRELLA

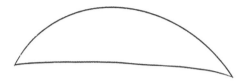

1 The basic exterior shape of the canopy is a very simple semi-circle. Sketch this out, using a lightly curved line along the base.

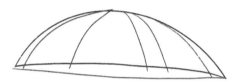

2 To give a 3D effect, draw an ellipse on the lower edge and then add the panels to the canopy.

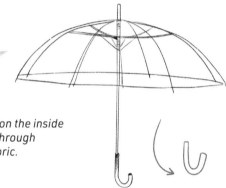

The stretchers on the inside will be visible through transparent fabric.

3 Add the pole through the centre, with a curved handle at the base and an end tip, or ferrule, at the top.

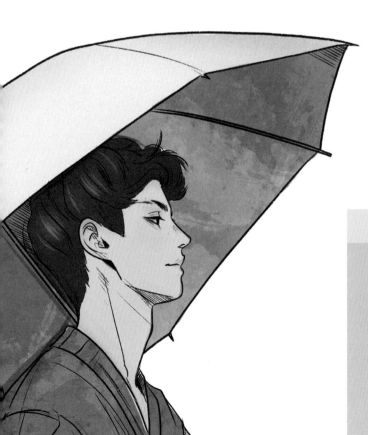

MANGA ART SECRET

Use an open umbrella to focus on and frame your character's face. Draw an ellipse, or eye shape, for the outline, then add details such as the ribs between the canopy sections. Shade in the interior and incorporate the pose in proportion to the rest of the figure.

SUMMER OUTFITS

Clothes for warmer weather are usually light, with shorter hemlines and cropped tops. I've put together a whole summer outfit here for a female character, replacing shorts or a sundress with a playsuit that combines the top and bottom in one, and looks both chic and casual. To complete the outfit, I've drawn a beach bag and floppy hat.

PLAYSUIT

A playsuit combines elegance and comfort. To make it look even more chic, I've added a belt. It's not difficult to draw but will make your finished drawing look more complex.

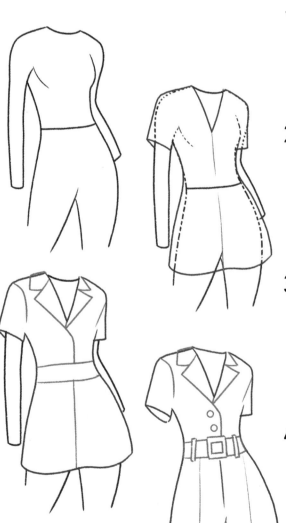

1 Start with the basic pose of the body, noting the position of the waist and hips, as these will guide the fit of the playsuit.

2 Add a general outline for the garment, keeping it just outside the initial lines as you don't want it to be super-tight –summer clothes should have a loose fit.

3 Refine the outline to add style details, such as the vest, the revere collar (flat v-shaped collars) and the waistband, with a split in the skirt for the shorts.

4 Personalise your outfit; here, I added buttons and a belt, which give the playsuit a summer-in-the-city feel.

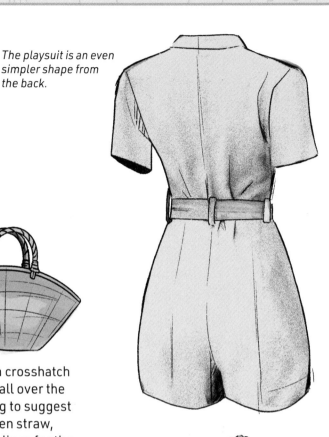

The playsuit is an even simpler shape from the back.

SUMMER TOTE

A straw bag will look great with the playsuit, and give the character a prop that adds something to their backstory. You can adapt this shape to a smaller handbag, or fill the bag with flowers!

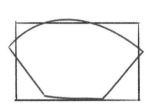

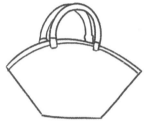

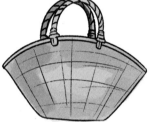

1 Draw a rectangle to serve as a guide for the bag's overall size and proportions. Draw a fan shape with a flat base in the box.

2 Add handles and a second line to mark the back of the bag, giving it a 3D effect.

3 Sketch a crosshatch pattern all over the main bag to suggest the woven straw, and add lines for the wrapped handles.

FLOPPY HATS

To draw the floppy, wide brim on a summer hat, break the steps down, starting with the crown and adding the outer, then inner shapes of the brim.

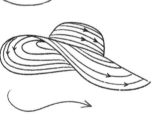

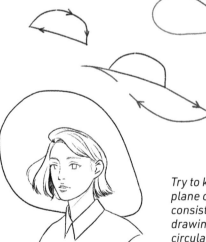

Try to keep the plane of the hat consistent when drawing a wide, circular brim.

MANGA ART SECRET

Drawing in manga style means you can simplify details, so that, for example, the woven pattern on a straw bag or hat doesn't need to be precise or realistic – you can still communicate the effect with just a few sketched lines.

Practise drawing the classic long overcoat from different angles, so you can wrap up your character in style. See pages 54–55 for alternative cuts and shapes.

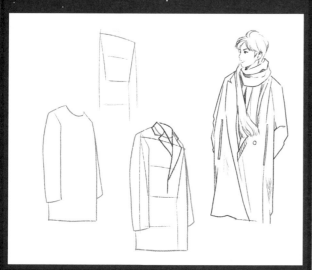

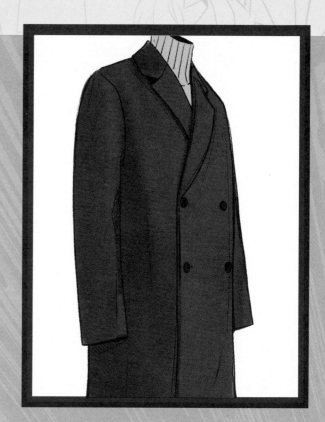

EXERCISE ROUND-UP

Follow the exercises to dress your character for any season. Once you're mastered the individual elements, try to combine them in one drawing to add to your narrative.

Using the foot as a guide, draw a Wellington boot with a generous fit that is slightly shaped around the calves. Add finishing touches as detailed on page 56.

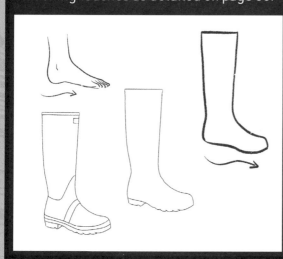

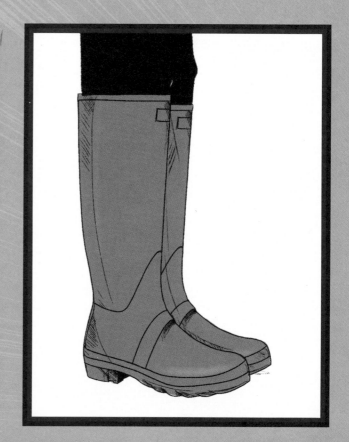

To draw a rain poncho (see page 56) from the side, break the shape down into simple shapes, adding fluid lines for the sweep of the hem and sleeves.

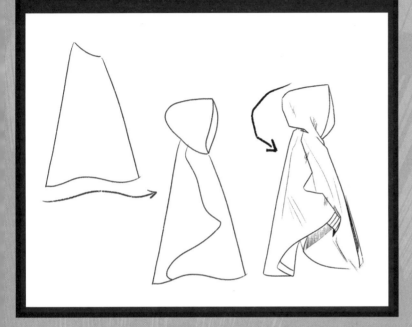

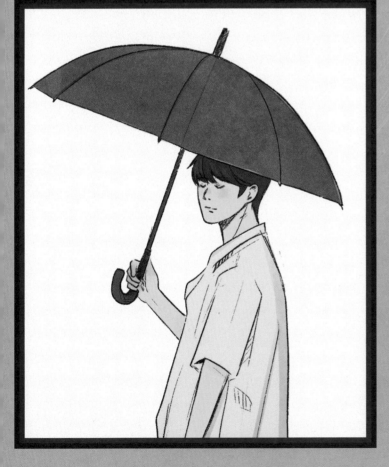

Starting with the basic ellipse, add an umbrella to your pose to suggest inclement weather. See page 57 for how to show transparent or rolled-up umbrellas, too.

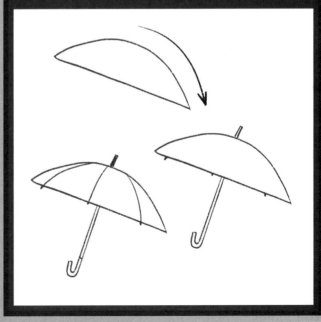

ARUNYI (@ARUNYI_)

I am Arunyi, a freelance artist from Portugal. Since I was a kid, I was inspired by anime to create and draw my own colourful characters and I have been drawing ever since. My biggest inspirations for character design are the Renaissance and baroque art styles – I love to recreate them with a bit of a manga twist! My drawing is also inspired by many other themes, from cute characters in soft pastels to dark and dramatic goths!

MANGA ART SECRET

When creating an outfit, I always pick a theme or aesthetic to help me create a balanced style. I then research the theme and try to think out of the box to create a unique design!

4.

ELEGANT CLOTHING

Introducing a touch of glamour, romance or old-fashioned elegance is straightforward when you choose to dress your character in gorgeous evening gowns and dapper suits.

FORMAL
ROMANTIC
TIMELESS
TAILORED
CLASSIC

BESPOKE
DRAMATIC
PROM
GLAMOUR

OCCASION DRESSES

A glamorous evening dress is the perfect choice if you want to make your character look elegant. Drawing these dresses is great fun – once you have a basic shape you can adapt it infinite ways. I'll show you how to analyse the female figure and base your dress on its form to give you a foundation for your creative designs.

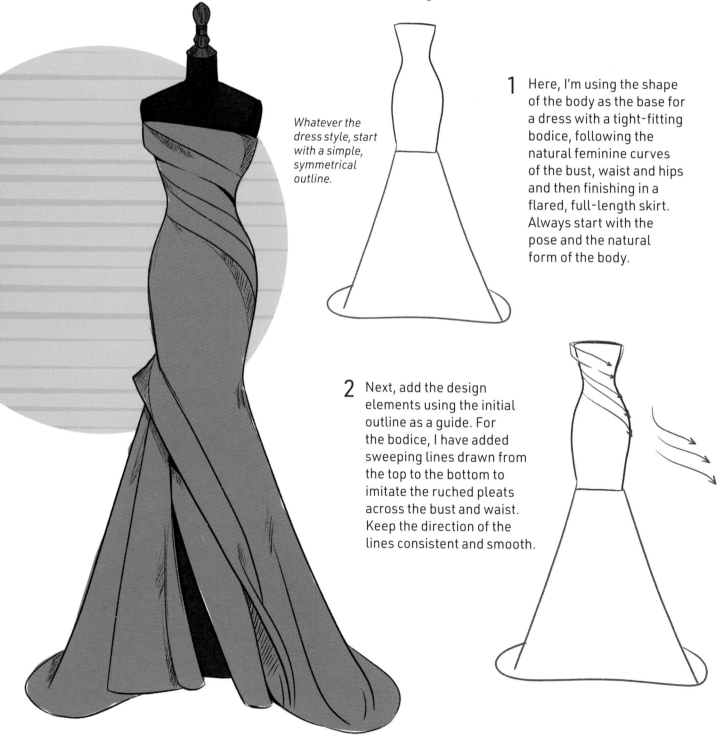

Whatever the dress style, start with a simple, symmetrical outline.

1 Here, I'm using the shape of the body as the base for a dress with a tight-fitting bodice, following the natural feminine curves of the bust, waist and hips and then finishing in a flared, full-length skirt. Always start with the pose and the natural form of the body.

2 Next, add the design elements using the initial outline as a guide. For the bodice, I have added sweeping lines drawn from the top to the bottom to imitate the ruched pleats across the bust and waist. Keep the direction of the lines consistent and smooth.

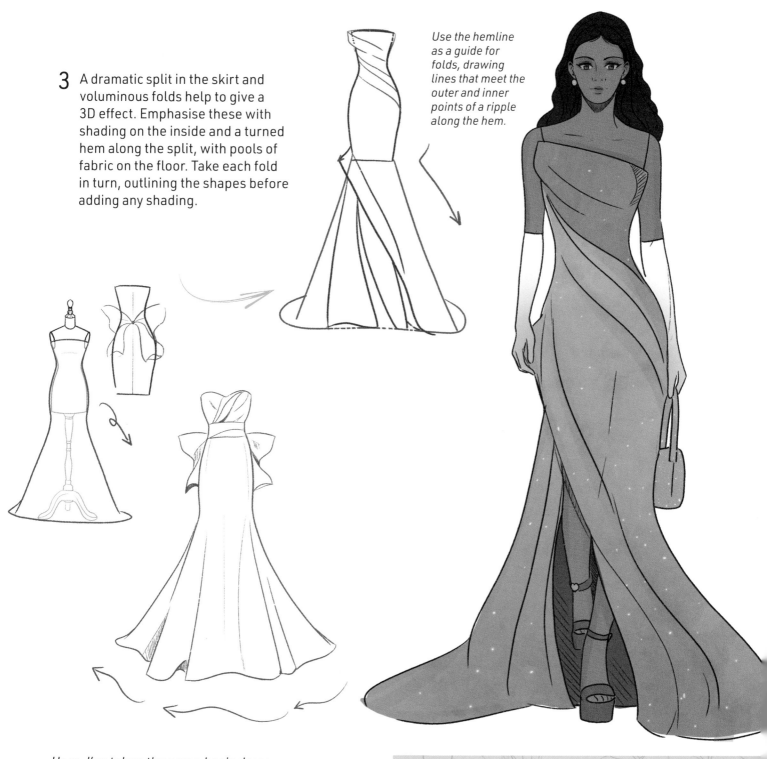

3 A dramatic split in the skirt and voluminous folds help to give a 3D effect. Emphasise these with shading on the inside and a turned hem along the split, with pools of fabric on the floor. Take each fold in turn, outlining the shapes before adding any shading.

Use the hemline as a guide for folds, drawing lines that meet the outer and inner points of a ripple along the hem.

Here, I've taken the same basic dress shape but added a sweetheart neck-line and an extravagant, oversized bow to the back. It's important to keep the position of these elements consistent when seen from the front, back or side.

MANGA ART SECRET
To keep things consistent when drawing the same element from different angles, imagine you are working on a dressmaker's dummy that you can turn and view from all sides.

It's easy to get swept away with the beauty of evening dresses once you start drawing them and you will soon begin to adapt one idea into another to build up your own 'collection'.

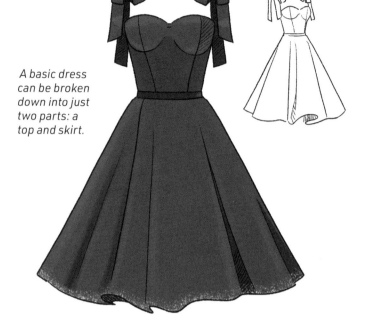

A basic dress can be broken down into just two parts: a top and skirt.

SHORT A-LINE SKIRTS

Shorter hemlines give a more youthful vibe to evening wear but with just as much scope for glamour and elegance as a traditional ballgown.

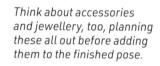

Think about accessories and jewellery, too, planning these all out before adding them to the finished pose.

HIGH-LOW STYLE

Changing the length, varying the neckline, adding sleeves or straps, or going strapless are all possibilities.

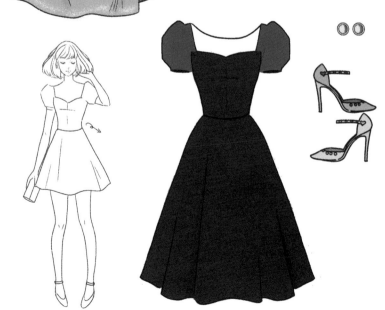

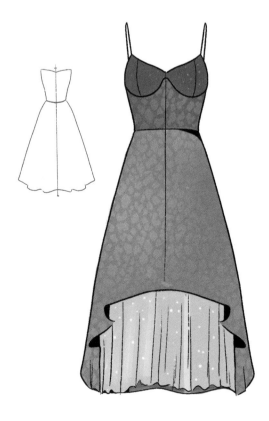

FLOOR LENGTH

These three gown variations demonstrate how you can adapt a base style with simple changes that result in very different looks.

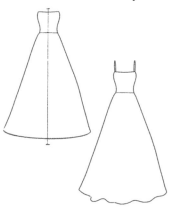

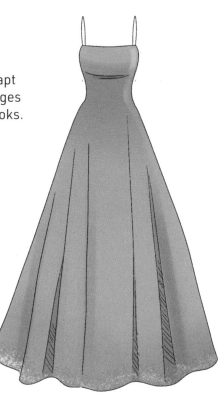

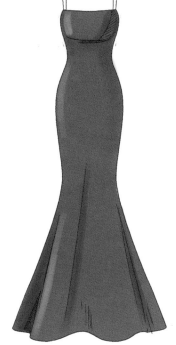

Circle

Fishtail pleats

Column effect

SWEETHEART NECKLINE

A full skirt and fitted bodice suggest a classic prom dress look. This neckline will accentuate the décolletage.

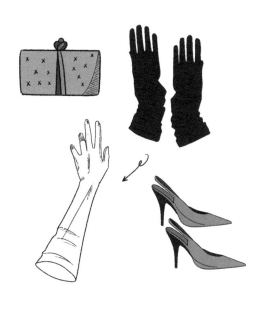

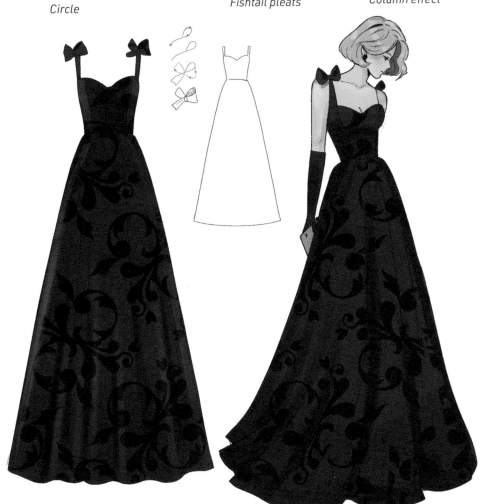

BALLGOWN OUTFIT

Here, we're going to draw a full outfit for our character – everything from the braided hairstyle to the earrings. Start with a concept for the whole gown – I like to draw my design on a dressmaker's dummy. Then, sketch the basic pose and begin to 'dress' it, adding the top, sleeves and skirt, then the accessories, one piece at a time.

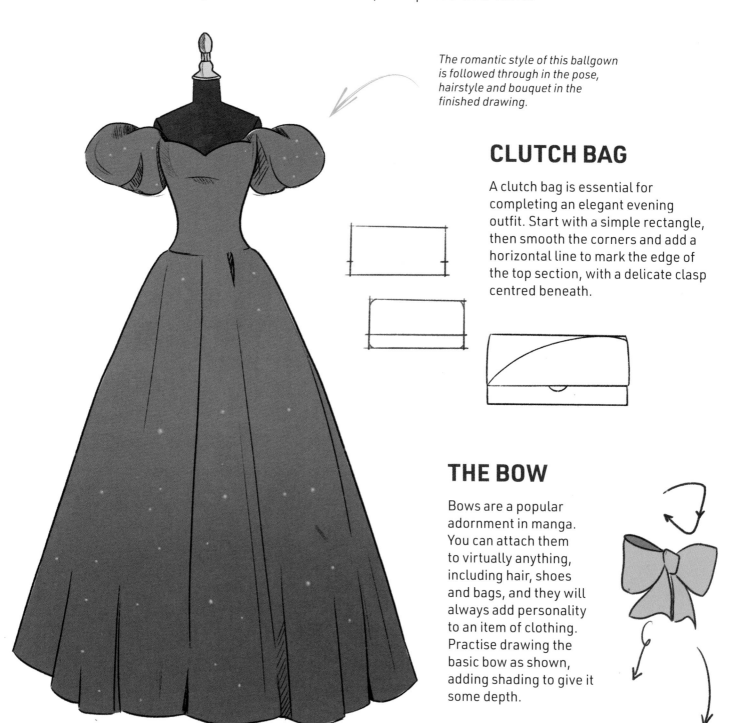

The romantic style of this ballgown is followed through in the pose, hairstyle and bouquet in the finished drawing.

CLUTCH BAG

A clutch bag is essential for completing an elegant evening outfit. Start with a simple rectangle, then smooth the corners and add a horizontal line to mark the edge of the top section, with a delicate clasp centred beneath.

THE BOW

Bows are a popular adornment in manga. You can attach them to virtually anything, including hair, shoes and bags, and they will always add personality to an item of clothing. Practise drawing the basic bow as shown, adding shading to give it some depth.

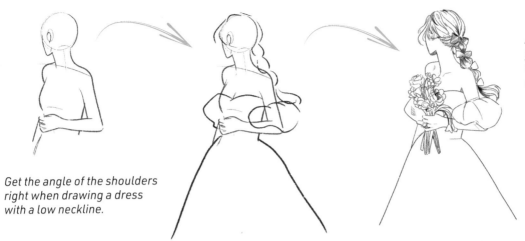

Get the angle of the shoulders right when drawing a dress with a low neckline.

A side profile means you can make a feature of your chosen hairstyle.

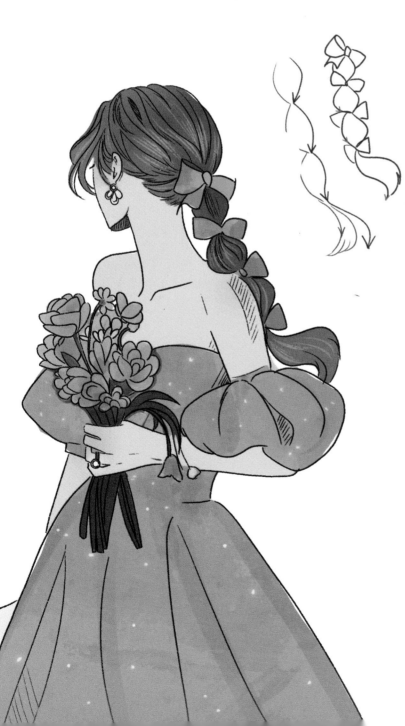

DECORATED BRAID

To draw a braid, outline the segments separately, making sure that each side connects at the same place and creates a rhythmic pattern. Make small variations in the size and shape of each segment to give the braid a natural feel, and draw the loose strands at the end in a dynamic sweep.

ACCESSORIES

To add earrings, draw the ear as a guide to the correct proportions and simplify the earring to the exterior shape, then draw another line inside to suggest the facet.

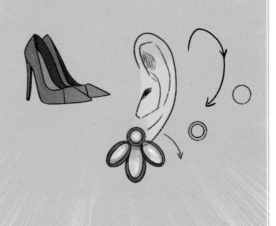

SUITS

There is no doubt that a suit exudes elegance and refinement. The definition of formality, it is a look that works for the office, graduation, weddings and evening wear. As this outfit requires multiple elements, take your drawing one stage or layer at a time.

There are many suit styles to consider, from the simple jacket and trousers combo, to the more formal three-piece look with a matching waist-coat, or change up the lapels and add a bow tie.

SUIT TROUSERS

Let's look at how to draw trousers to match our suit jacket. Formal slacks are relatively straight and narrow, so start with a simplified outline that follows the leg shape and length. I've drawn a slim-fit style with tapered legs, so the fit is only a little wider than the body. Shape the trousers slightly, adding details such as the waistband, fly and pockets. A central crease gives an elegant finish down each leg, and look for folds and wrinkles as these trousers are tight-fitting.

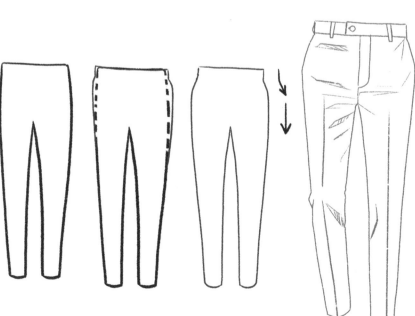

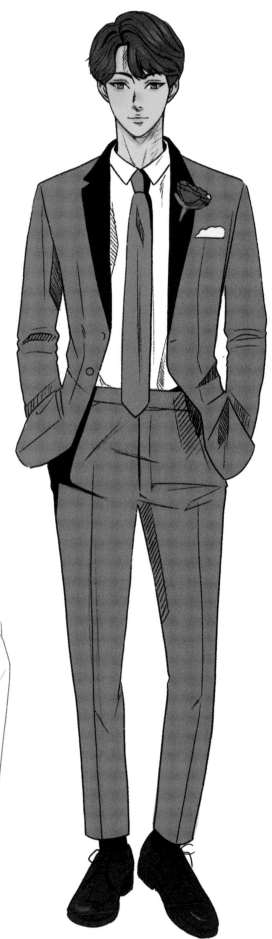

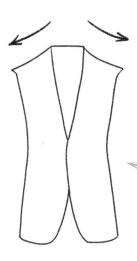

FORMAL JACKET

1 Break the shape down into two parts: the middle section and the sleeves. Start with a rectangular shape that finishes at the hips.

2 Split the rectangle in half with a V-shape neckline and curved hems. Adjust the angle of the shoulders and add the sleeves, ensuring they are level.

The key to drawing a jacket from the front or back view is symmetry.

3 Add the jacket details: the lapels should be symmetrical and the pocket flaps positioned along the same plane. Place the buttons.

4 Try to visualise the hidden elements beneath the jacket – a shirt and tie, and sometimes a waistcoat (see page 74) – and work in layers to complete the look.

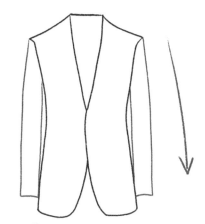

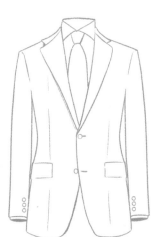

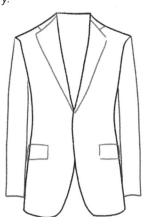

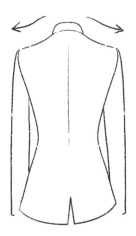

LAPELS
Jacket lapels can be a dominant feature with a style of their own, whether in a contrasting fabric like satin or velvet, a different colour, or just larger than average.

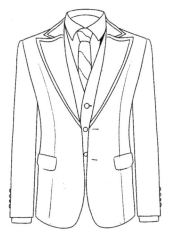

From the back

Make sure the lines and curves are as smooth as possible, drawing them from top to bottom.

MANGA ART SECRET
For an accurate drawing of a suit jacket, it's important to capture the natural slope of the shoulders and reflect this in the jacket's tailoring. Use the shape of the torso as a guide.

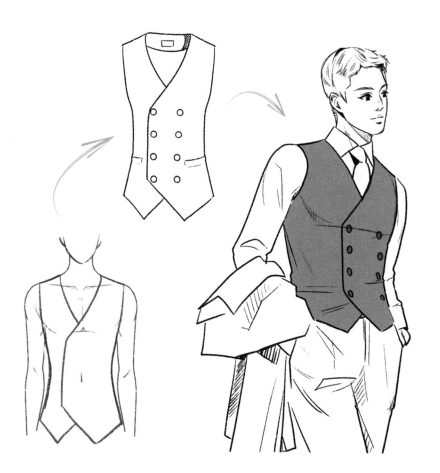

THE WAISTCOAT

A waistcoat completes a three-piece suit and will give your character a refined air. Approach drawing a waistcoat in a similar way to a jacket (see page 73), but note that the waistcoat is a tighter fit and takes the shape of the body. Start with an outline of the torso to help guide the width of the chest and where the waistcoat sits on the hips. There are many waistcoat styles – patterned and plain, single- or double-breasted – so adapt to match your character's personality.

BOW TIE

Considered part of the five-piece suit along with a dress shirt, a bow tie suggests formal occasions and traditional elegance. Bow ties are simple to draw; start with the middle section, then add each side.

Avoid rigid outlines, instead draw rounded shapes that look more natural.

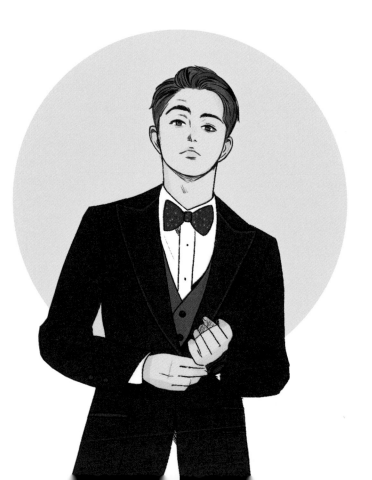

NECK TIES

A neck tie is an essential finishing touch to a formal suit. They should be drawn alongside the shirt collar as the two are naturally connected. Nestle the knot between the collar points, and keep the tongue parallel and symmetrical down its length.

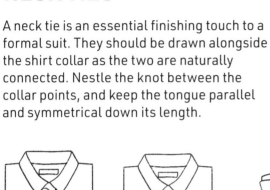

If the tip of the neck tie appears separately, keep it aligned with the top part for a professional finish.

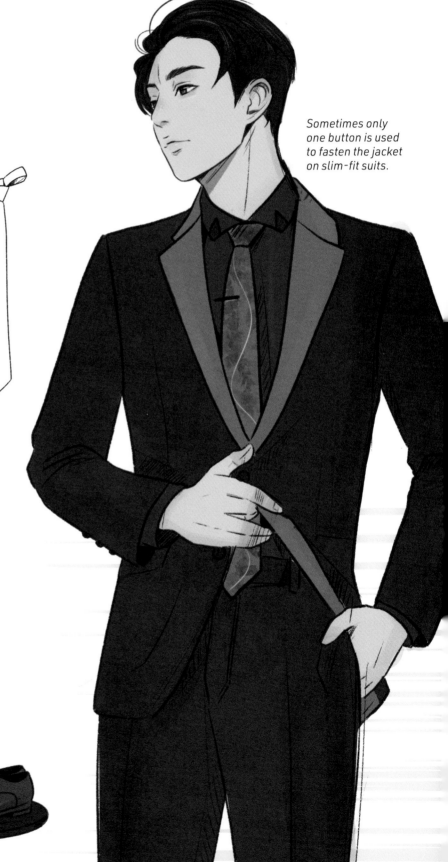

Sometimes only one button is used to fasten the jacket on slim-fit suits.

DRESS SHOES

Footwear plays an important part in creating a sense of style and flair. For both male and female characters you have a huge choice of styles and materials. Male dress shoes tend to be either a traditional laced Oxford or brogue, or slip-on loafer. For female characters, high heels are called for, adding height and glamour to the overall look. Take inspiration from the illustrations shown here to create your own unique pairs.

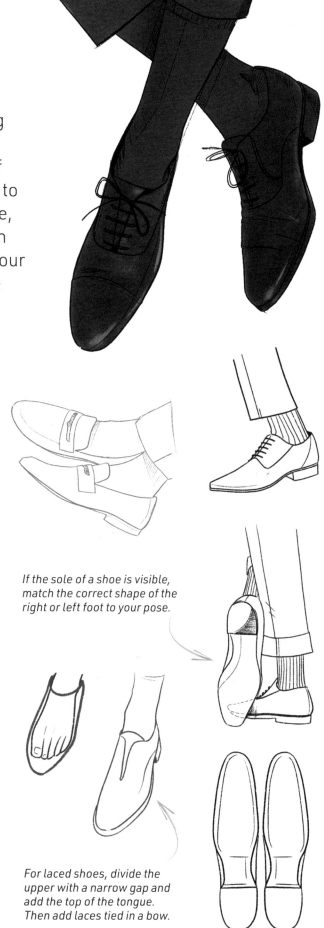

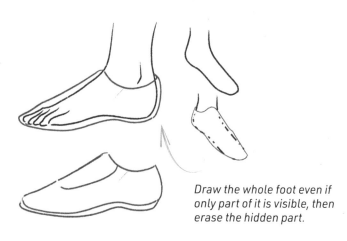

Draw the whole foot even if only part of it is visible, then erase the hidden part.

If the sole of a shoe is visible, match the correct shape of the right or left foot to your pose.

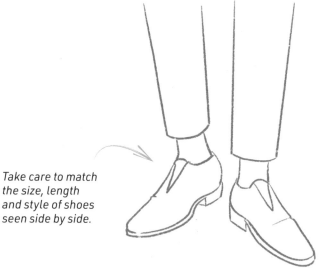

Take care to match the size, length and style of shoes seen side by side.

For laced shoes, divide the upper with a narrow gap and add the top of the tongue. Then add laces tied in a bow.

THE HIGH HEEL

You can have a lot of fun designing shoes to match your character's evening wear. In general, a high heel shoe is slim and close-fitting, with strappy versions revealing the foot and toes. Drawing a high heel shoe follows the same principles as for male dress shoes, but it is the height of the heel and its effect on the foot shape that you need to take into consideration.

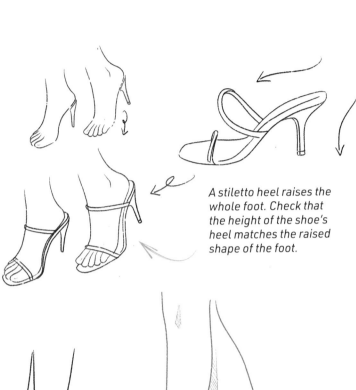

A stiletto heel raises the whole foot. Check that the height of the shoe's heel matches the raised shape of the foot.

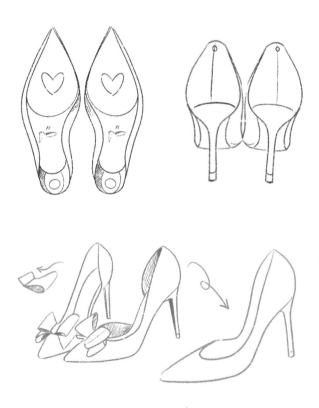

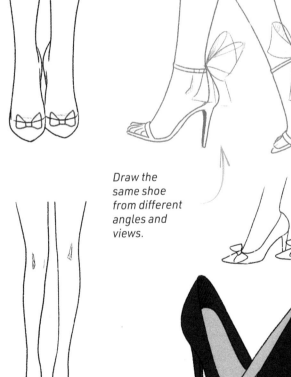

Draw the same shoe from different angles and views.

Decide on the position of the feet and the type of shoe. Sketch a simplified foot, then draw an outline that follows the length of the foot and matches the contours. Establish the shoe's sole and heel, then add details specific to the shoe style.

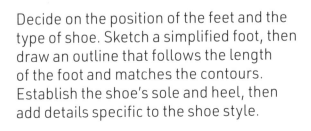

It helps to see a dress as two parts: the skirt and top. Practise drawing your favourite style by combining the two elements. See pages 66–69 for more dress ideas.

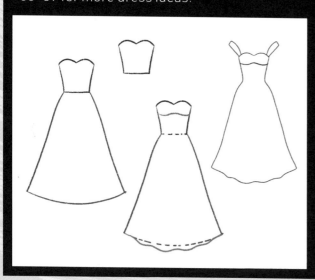

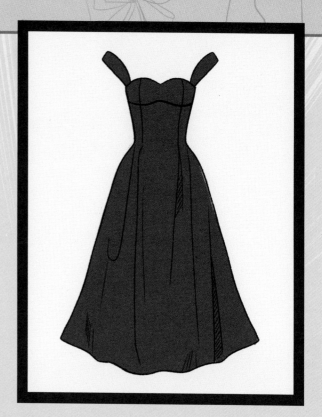

EXERCISE ROUND-UP

Create the perfect evening attire for your characters with a romantic ballgown, complemented with a dapper suit, and don't forget the dress shoes!

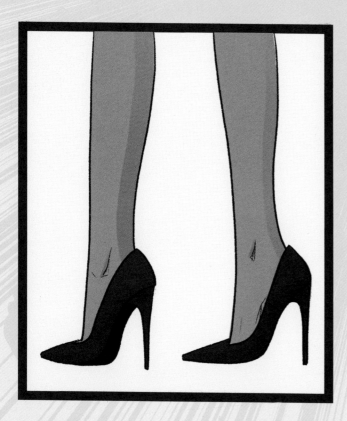

Refer to page 77 for help drawing the slim outline of a stiletto, following the shape of the foot and matching the height of the heel to the raised arch.

Draw each element of a suit, shirt and tie separately, starting with the torso and sleeves and keeping things balanced and sharp. See more suits on pages 72–75.

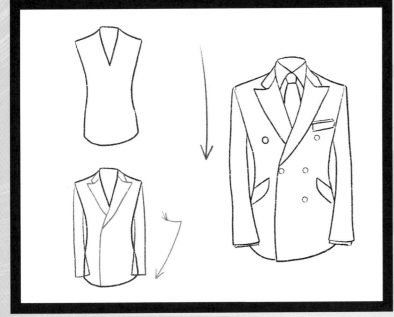

The key to drawing shoes is to match the shape to the outline of the foot. Keep the style simple to start with, referring to page 76 for more elaborate dress shoes.

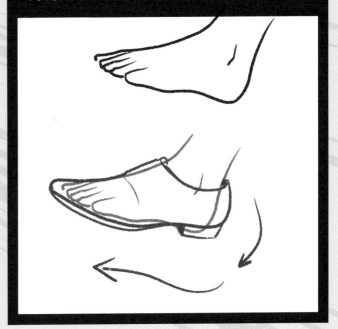

YUCKIE (@KIRAIXSUKI)

Hello! I'm Yuckie, a freelance illustrator from Brazil. I graduated in graphic design, but my current work is just with illustrations. My passion for art and drawing started when I was a kid – I was always designing clothes for myself and my characters, and dreaming of being a fashion stylist one day. Although I haven't fulfilled this part of my dream (yet), I can still express my inner stylist with beautiful clothes for my characters.

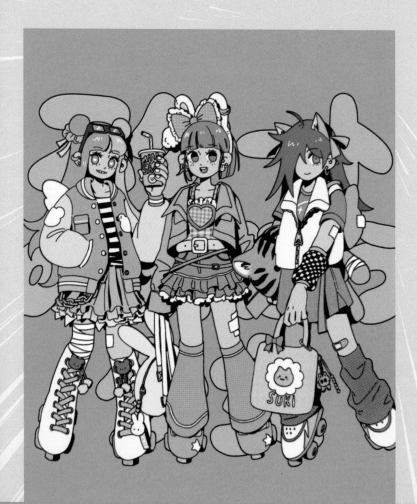

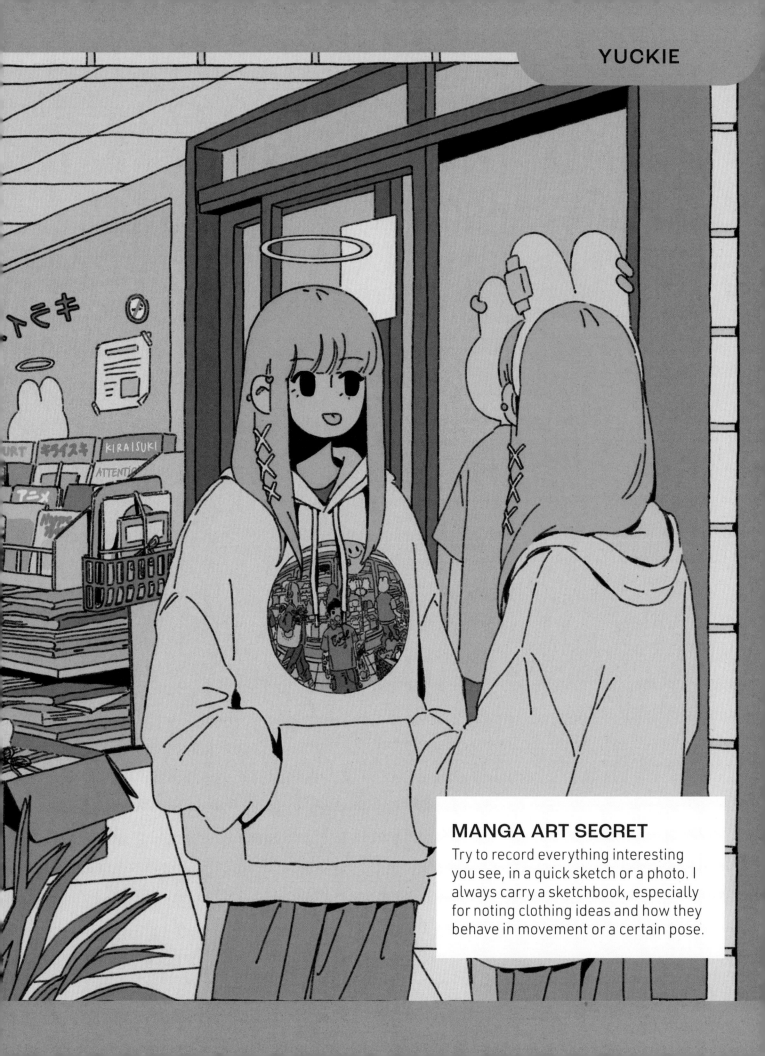

MANGA ART SECRET
Try to record everything interesting you see, in a quick sketch or a photo. I always carry a sketchbook, especially for noting clothing ideas and how they behave in movement or a certain pose.

5.

TRADITIONAL CLOTHING

The kimono is the quintessential garment that defines traditional Japanese clothing and I love drawing my characters dressed in national costume – the look is beautiful and I think it enriches their personality in a unique way.

TIMELESS
SILK
PATTERNED
MODEST
DECORATIVE

FORMAL
MARTIAL ARTS
WARRIOR

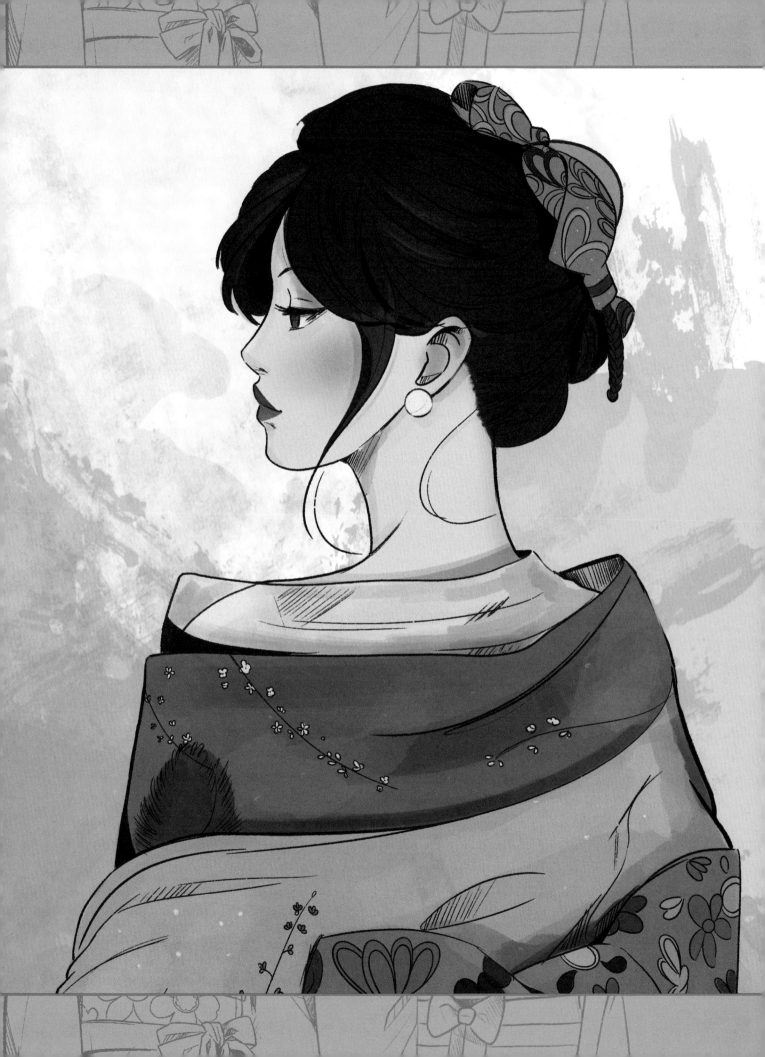

FEMALE KIMONO

Japanese fashion has a long history of beautiful clothing, and all the various components of traditional kimono-style make it fun to draw. The kimono is worn with a broad sash, called an obi, and accessories such as zōri sandals. The style of the kimono can vary depending on the occasion and season, but its overall design remains the same and is based on a simple T-shape.

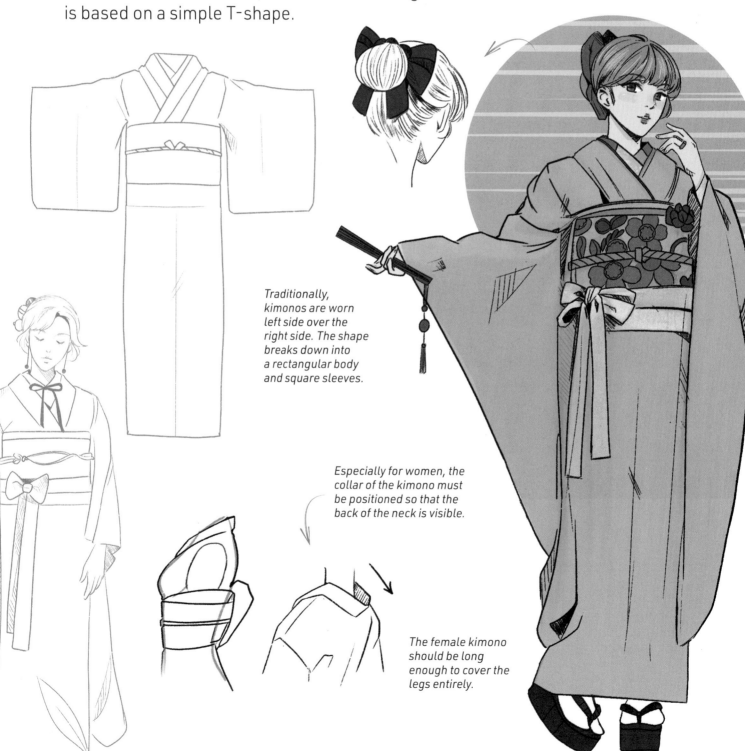

Traditionally, kimonos are worn left side over the right side. The shape breaks down into a rectangular body and square sleeves.

Especially for women, the collar of the kimono must be positioned so that the back of the neck is visible.

The female kimono should be long enough to cover the legs entirely.

THE OBI BELT

The obi belt is a wide strip of decorative fabric that is wrapped around the waist of the kimono to fasten it. The belt is tied with a bow, usually at the back, but you can also add bows to the side or front, making them as big and extravagant as you like. The style for women's obi differs slightly from men's, with colourful patterns related to nature, such as flowers and animals.

You can vary the size and shape of the obi. Tied at the back, they are useful for adding a decorative feature to a simple pose.

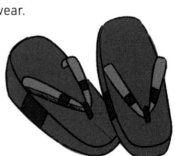

FAN

The hand fan is a nice accessory to complete a traditional outfit. To show an open fan, draw the wooden structure and a curve as a guide. Then add the the folds. Add a simple pattern to make the fan more appealing or even a tassel, as shown in the example.

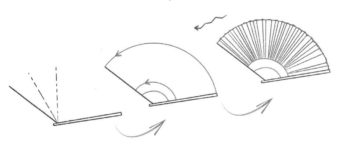

ZŌRI SANDALS

Similar to a flip-flop (see page 36), zōri sandals are traditional Japanese footwear designed to be slipped off easily when entering a home. The thong is often made of kimono fabric and the base is traditionally made from lacquered wood for a formal dress, or straw for day wear.

To give the wearer extra height, zōri have raised soles.

TABI

The tabi is a sock with a split toe. Traditionally worn with a kimono and zōri, it will make your character's outfit look authentic. Simply follow the foot shape and add a division after the large toe.

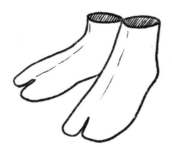

MANGA ART SECRET

You can have a lot of fun with accessories that complement an outfit to create a complete look. An object of beauty itself, a fan or ornamental comb will add another level of sumptuous design to a traditional kimono outfit.

MALE KIMONO

With a similar shape to the female version, a male kimono is generally shorter and is traditionally worn with hakama trousers, which have a loose fit and a pleated, wide-leg style. Other differences include a narrower obi belt in subtle colours and patterns, compared to the more decorative and flamboyant female sash.

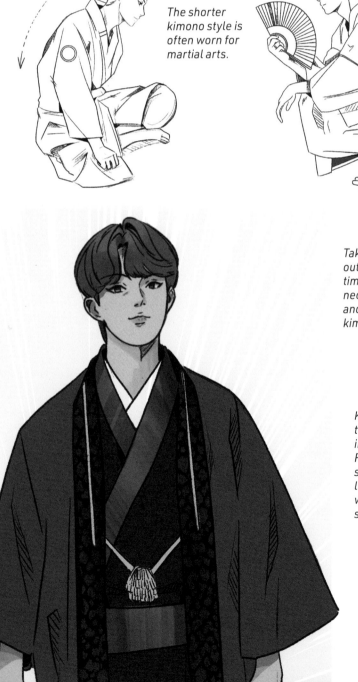

The shorter kimono style is often worn for martial arts.

To help capture the loose-fit of a kimono, you need to master the drapes and folds of the fabric. Look carefully at the full sleeves and the tension and creases that follow the crossover neckline.

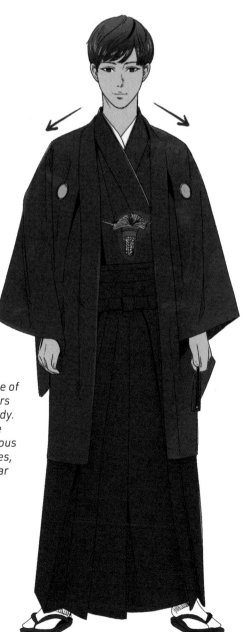

Take each layer of the outfit one step at a time, starting with the neckline and shoulders and adding the obi and kimono on top.

Keep the simple outline of the kimono and trousers in proportion to the body. Follow the slope of the shoulders in a continuous line for the wide sleeves, which make a triangular shape at the hem.

SWORDS

The Japanese warrior is a popular theme in manga, along with traditional weapons. The samurai sword, or katana, is the most commonly used in illustrations and combining a weapon with a warrior pose will bring instant authenticity to your drawing. Practise drawing the sweeping curve of the blade and the carved details of the guard before adding it to your work.

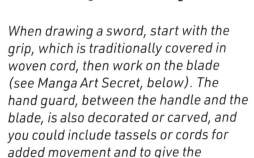

When drawing a sword, start with the grip, which is traditionally covered in woven cord, then work on the blade (see Manga Art Secret, below). The hand guard, between the handle and the blade, is also decorated or carved, and you could include tassels or cords for added movement and to give the character an air of importance.

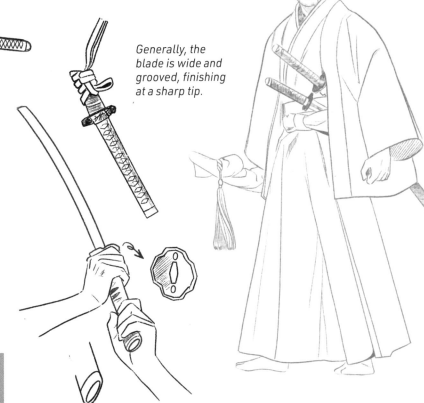

Generally, the blade is wide and grooved, finishing at a sharp tip.

MANGA ART SECRET
Drawing the long, smooth curve of a sword blade can be quite difficult and it may take several attempts to achieve a perfect line, especially with long strokes. To make it easier, draw three dots: one at the tip, one in the middle and one at the hilt. Now try to connect the dots with a continuous, smooth line from top to bottom.

Visualise the kimono as a T-shape to help you practise drawing it. Start with a rectangular body, then add the sleeves the full length of the arm. See page 84 for more ideas.

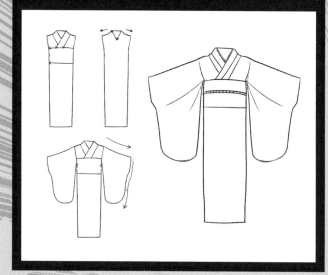

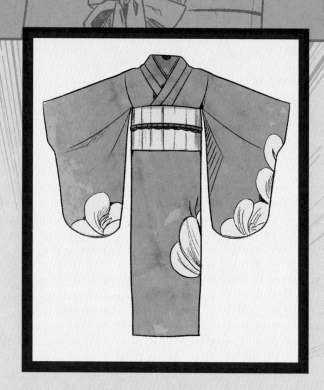

EXERCISE ROUND-UP

To create a traditional costume for your manga character, immerse yourself in sumptuous kimono designs, and capture the power of an armed warrior. Take each element and practise perfecting the style.

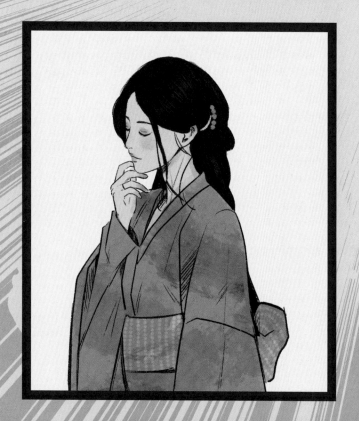

Break an obi down into simple shapes. Follow the steps below to add a large bow to a female kimono.

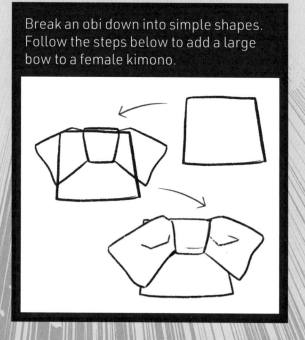

To master drawing a sword, follow the sequence of steps below and see page 87 for more tips on perfecting the smooth curve of the katana's blade.

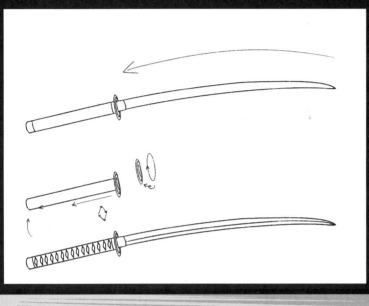

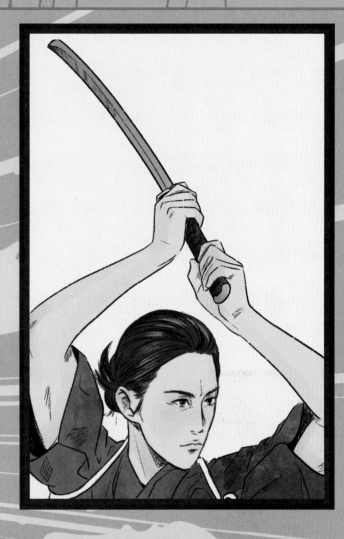

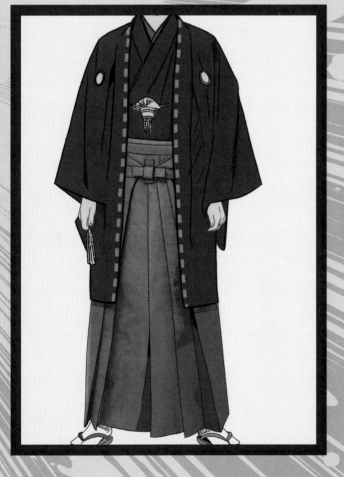

For a male kimono, build the outfit in layers, using the full length of the body. See page 86 for more ideas.

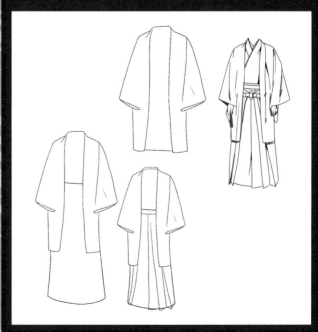

DIANA (@DIANA1992D)

I am Diana, a self-taught artist and the twin sister of Dalia, the author of this book. I watched a lot of Disney movies as I was growing up, learning the songs and scripts by heart as I rewatched each movie, and they inspired my interest in drawing. I started out with a realistic style and moved on to anime until I developed my current style. My advice is to keep on exploring various styles until you find one you really enjoy, then you will see progress!

MANGA ART SECRET

When looking for references for your character's clothing, don't just look at other drawings but use photographs, web images and even the real thing if it's something you have in the wardrobe!

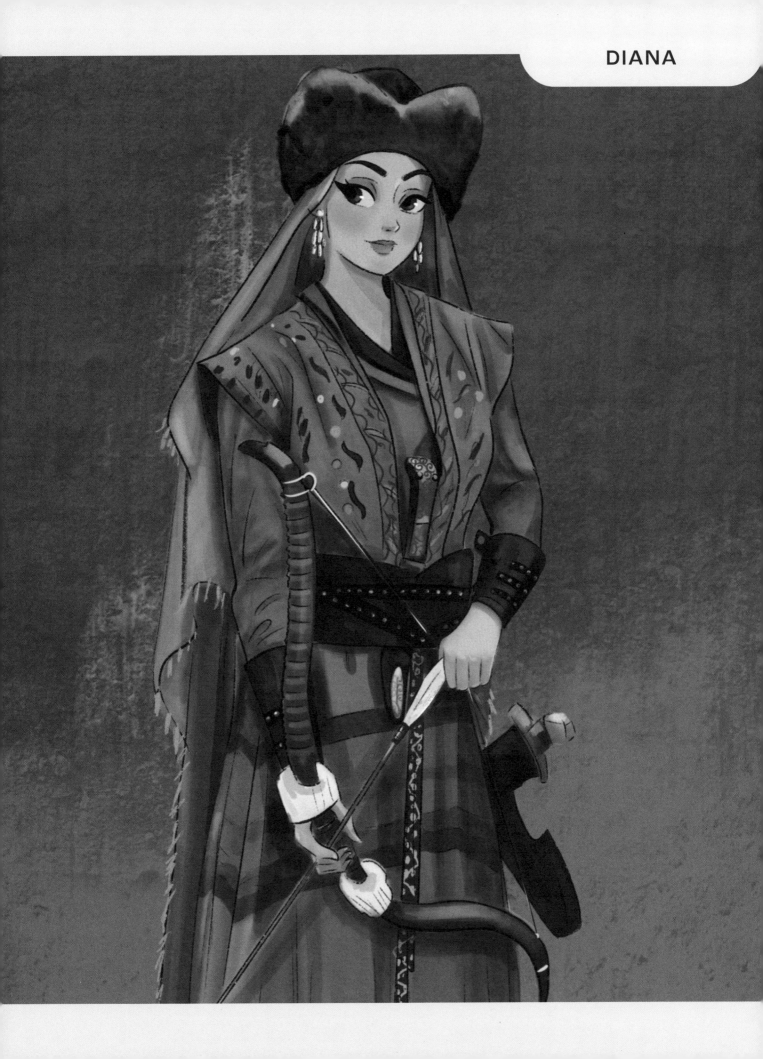

6.

SPORTSWEAR

Have fun exploring all the different styles of activewear that are worn for sports activities. Sport is a popular theme in manga, giving you the chance to include dynamic poses and give your character a competitive personality.

PRACTICAL **FLEXIBLE**
COMFORTABLE **STRETCH**
ACTIVE **LIGHT**
STREAMLINED
HIGH TECH

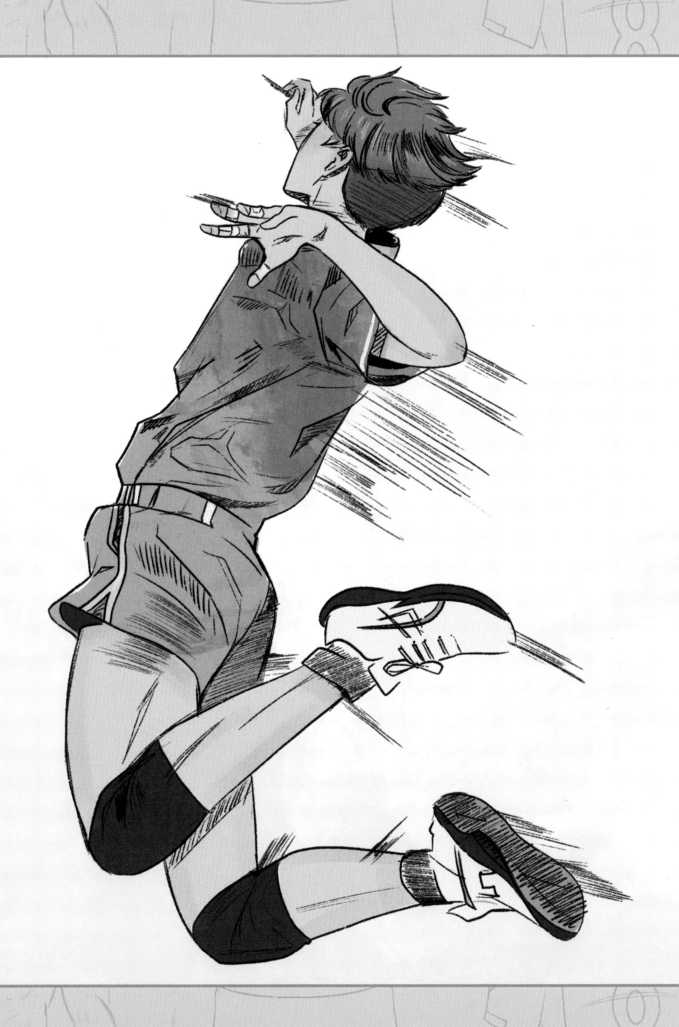

BASKETBALL KIT

Basketball is one of the most popular sports in manga. Players are identified by their loose-fitting jerseys and baggy shorts in team colours. To draw a player in action, start with the pose and build the kit on top in layers, using the folds and creases to emphasise the direction of movement.

The speed and deft moves of basketball players means that their kit needs to allow for unrestricted movement. A loose-fitting top or vest is paired with long, wide shorts in synthetic fabrics that flow easily.

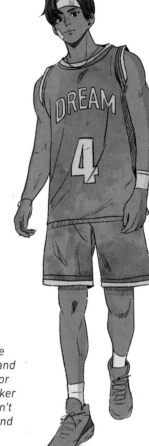

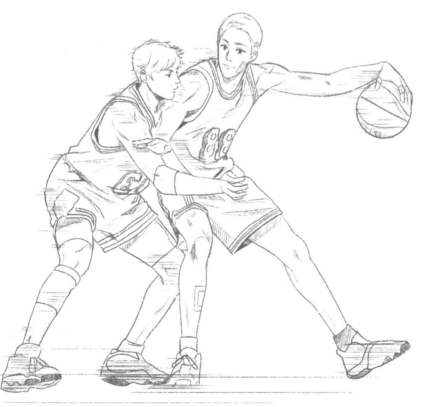

The full kit should include the number on the front and back. Use a light colour for the home team and a darker kit for a visiting team. Don't forget high top trainers and the ball!

When wearing a vest, the player's physique will be visible, so take time to study the shapes of muscles in dynamic poses, using other manga illustrations and stills from real-life games to help you.

VOLLEYBALL KIT

The kit for volleyball is similar but you can differentiate it by a tighter-fitting vest or jersey that reveals rather than conceals the player's physique.

The kit for volleyball is a much tighter fit in order to avoid the danger of touching the net, which is prohibited. Similar to drawing a tight-fitting T-shirt (see page 40), use the outline of the muscles on the arms and chest to emphasise the fit.

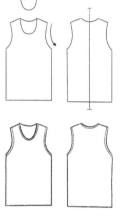

Front Back

Front Back

1 Start with a simple outline of the basic rectangular shape for the vest or tee.

2 Use a dividing line to help keep the shape symmetrical as you add the neckline and the armholes.

3 Follow the slope of the shoulders closely, adding short sleeves to match the width of the arms.

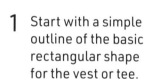

To make your characters part of a team, shade their kit in matching colours.

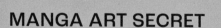

MANGA ART SECRET
To draw a basketball, start with a circle and add a gently curved vertical line off-centre. Intersect this with a horizontal half-moon shape across the top. Now add an oval shape for the quadrant and finish with a classic orange shade.

GOLF ATTIRE

Of all the sports, golf has a readily identifiable fashion style that gives it an air of sophistication and formality, putting it in a class above the rest. Communicate this status by dressing your character in the smartest attire, ready to hit the fairway.

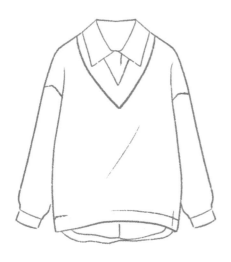

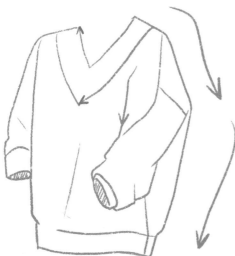

Dressing for a round of golf involves clothes that are generally made from light materials, layered for warmth and loose for ease of movement. Female players have lots of options in addition to a jumper or polo shirt, wearing cropped trousers, skorts, shirts or dresses. Male players must wear trousers and a shirt.

To achieve a smooth, more accurate result as you draw, follow the direction of the arrows, working from top to bottom.

Golf socks and shoes have very specific designs and styles, so pay attention to these details to make your drawing accurate.

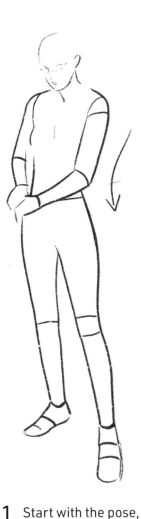

2 For this outfit we are drawing a vest with a V-neck, so sketch in the outline, using the body as a guide. Extend the lines beyond the torso to give volume to the jumper and keep the fit loose.

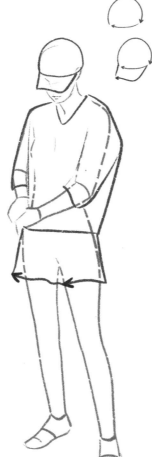

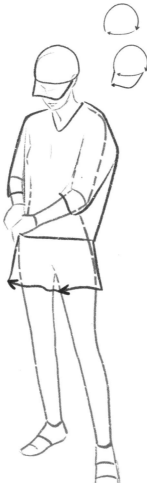

4 Add a few details to finish the outfit – a contrast band around the vest neckline, shorts or a skort and shoes. Position the golf club so that it connects to the ground in line with the shoes.

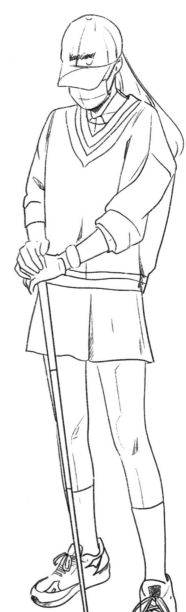

1 Start with the pose, outlining the body and noting the proportions (see pages 11–12). The outfit isn't tight-fitting but the shape will follow the body, especially at joints such as elbows, where the sleeve finishes.

3 Adding a cap is simple if you just follow the shape of the head, following the downward tilt so that the visor covers the eyes. Practise drawing the whole cap a few times to familiarise yourself with its shape.

ACCESSORIES

Golf attire follows a strict dress code and this means that even accessories, such as caps, gloves and shoes, also need to be specific to the sport – no fitness wear or casual clothing is allowed! See page 102 for more on drawing gloves.

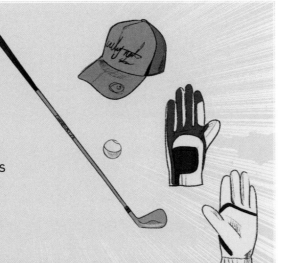

BALLET COSTUMES

Ballet costumes are designed to give dancers freedom of movement and enhance the visual effect of their choreography. The main clothing pieces specific to ballet are the leotard, dance tights or leggings, a tutu and pointe shoes.

Sleeveless, short-sleeved and long-sleeved leotards are all options for ballet.

The multi-layered tutu gives the ballerina the illusion of lightness and flight, and its short length means that the graceful legs are visible. Tight leotards, and dance tights for men, are made from stretch materials that reveal the muscle tone beneath.

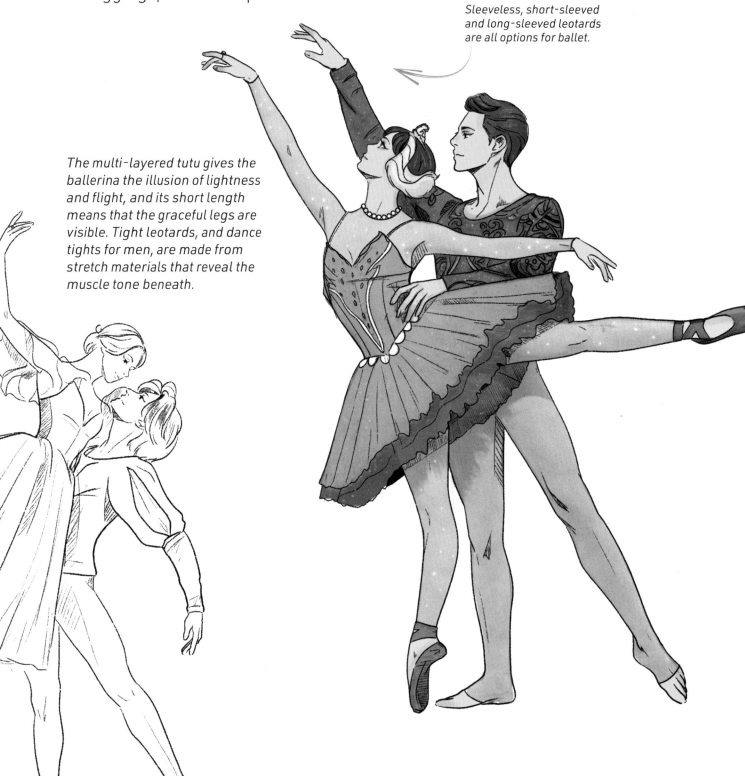

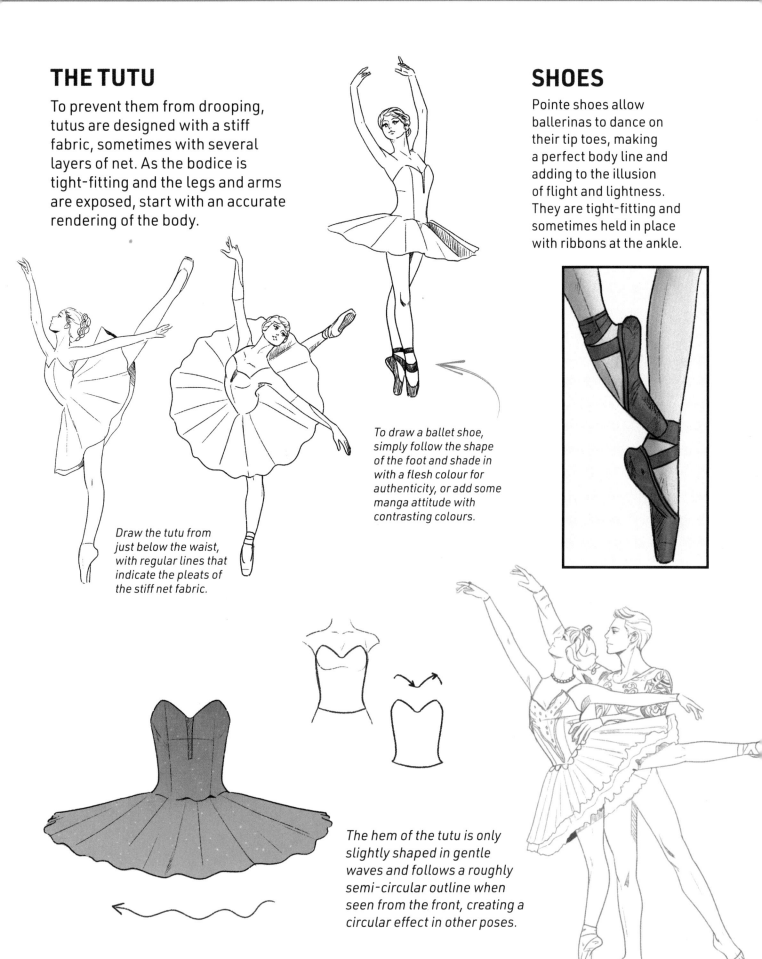

THE TUTU

To prevent them from drooping, tutus are designed with a stiff fabric, sometimes with several layers of net. As the bodice is tight-fitting and the legs and arms are exposed, start with an accurate rendering of the body.

Draw the tutu from just below the waist, with regular lines that indicate the pleats of the stiff net fabric.

SHOES

Pointe shoes allow ballerinas to dance on their tip toes, making a perfect body line and adding to the illusion of flight and lightness. They are tight-fitting and sometimes held in place with ribbons at the ankle.

To draw a ballet shoe, simply follow the shape of the foot and shade in with a flesh colour for authenticity, or add some manga attitude with contrasting colours.

The hem of the tutu is only slightly shaped in gentle waves and follows a roughly semi-circular outline when seen from the front, creating a circular effect in other poses.

FOOTBALL KIT

On a global scale, football (or soccer) is possibly the most popular sport both to play and to watch. A football kit is easily identifiable with just a jersey tee and shorts in team colours – you can choose from real-life teams or invent your own colour scheme. As football is an action sport, you'll need to master dynamic poses and how fabric is affected by different positions as the players run or kick the ball.

THE JERSEY

The football jersey is a simple T-shape that has a slim fit and is usually made from a thin fabric such as polyester. Using a rough sketch of the torso, start to draw the jersey with basic rectangular shapes. Define the neck and sleeves, with the main body of the jersey falling just outside the torso.

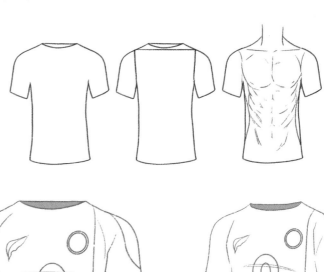

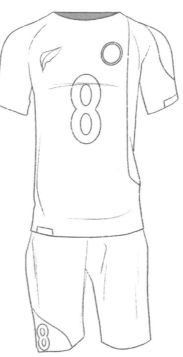

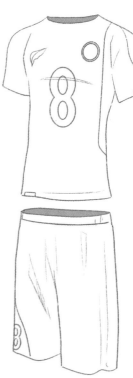

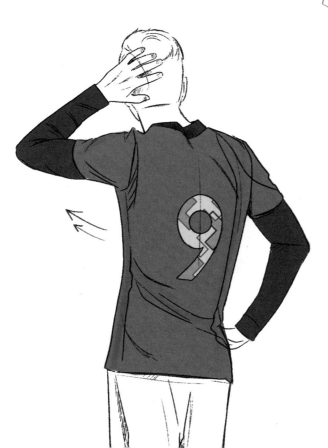

Add details like the club logo and the player's name and number. Football shorts are also in team colours, with a relatively loose fit, and made from a similar thin fabric as the jersey.

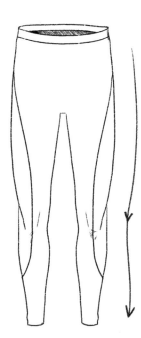

In cold weather, players may also wear leggings under their shorts. These have a tight fit and are simple to draw by following the shape of the leg, taking into account the curves of the thighs and calves that show the character's athletic build.

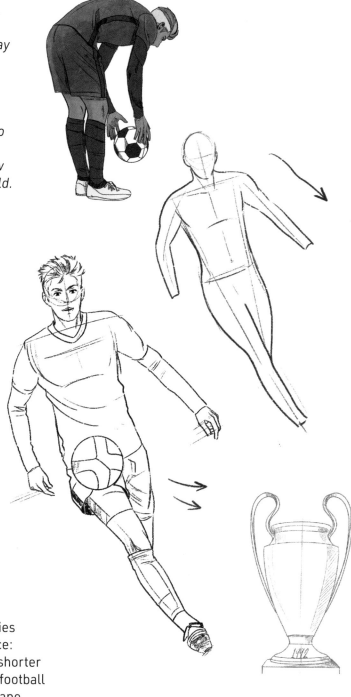

Keep in mind how you can use clothing to emphasise the dynamism of a pose, especially for football players, whose kit is made of light fabric that doesn't restrict movement. Use shadows inside the shorts to show the raised leg as it powers forward.

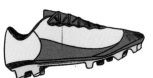

FOOTWEAR

The sole of football boots varies depending on the pitch surface: studs or spikes for grass and shorter studs for astro turf. To draw a football boot, start with the overall shape around the foot, then add the design elements or brand logo, and finally the spikes or studs to the base.

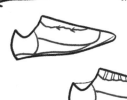

MANGA ART SECRET

In sport, where fast movement is involved, you can use motion lines to illustrate this sense of speed. Add abstract lines behind the moving object, such as a ball or the feet or legs of the player, for instant action.

SKI ACCESSORIES

Winter sports like skiing, sledging, ice skating and snowboarding are all part of an outdoor lifestyle that suggests high-octane thrills. Accessorising your character with all the kit associated with winter activities will give them instant style, ready for the slopes. Follow the instructions to add helmets, goggles, boots and gloves, and finish with a snowboard or skis for cool winter vibes.

Accessories help to communicate exactly what type of activity your character is interested in. Here, the snowboard is the key. You can incorporate this piece of equipment in several ways, but held casually under an arm it hints at a cool, nonchalant character. Build the details in the branding to achieve a complex sketch.

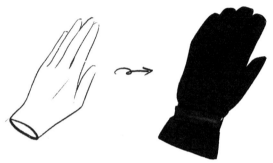

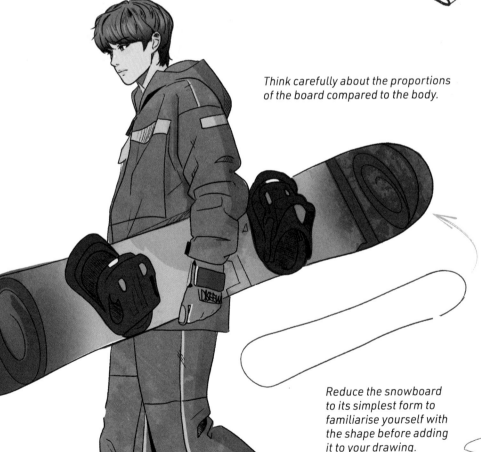

Think carefully about the proportions of the board compared to the body.

Reduce the snowboard to its simplest form to familiarise yourself with the shape before adding it to your drawing.

GLOVES

In general, gloves follow the same shape as the hand, but for winter gloves they tend to be bulkier. To indicate a well-insulated glove, follow the hand shape outside the guidelines, and thicken the fingers and thumb. Finish with a cuff and a crease line along the knuckles.

Ski boots are similar to rubber boots (see page 56), with thicker soles.

GOGGLES

Start by simplifying a pair of goggles into a couple of rectangular shapes. Modify the outline with smooth curves, using the underlying guidelines to help with proportions. When seen from the side you need to add a sense of depth and perspective to these 3D shapes – look at the angle of the strap and difference in lens size where they curve around the face.

HELMET

For the helmet, start with a circle to represent the head. I draw the helmet in two parts: the upper protective part that follows the curve of the head and the lower part that frames the face.

Start with an outline of the head, noting the angle and tilt.

Add the outline of the helmet and then the goggle shape on top.

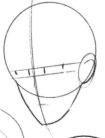

HEAD GEAR

Combining items can seem daunting but by breaking the elements down into layers you'll soon master the details. When resting on a helmet, draw goggles in proportion to the facial features and head.

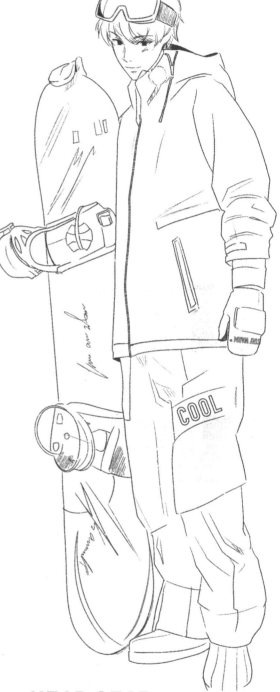

Using the football boot guidelines on page 101, draw a pair of trainers, adapting the sole to suit the sport and breaking each element of the design down into stages.

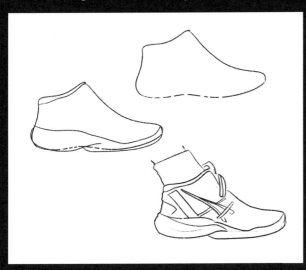

EXERCISE ROUND-UP

Recap the topics covered in this chapter by completing these exercises. As several sports share the same kit, include distinguishing items to help identify your character's specialism.

Keep drawing sports T-shirts, adapting the guidelines on page 95 to a tight or a loose, slim fit depending on the sport.

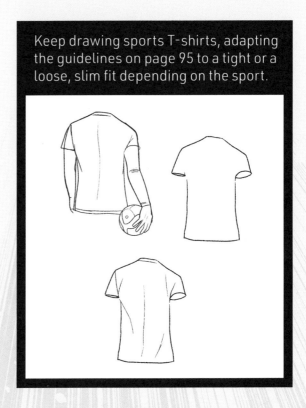

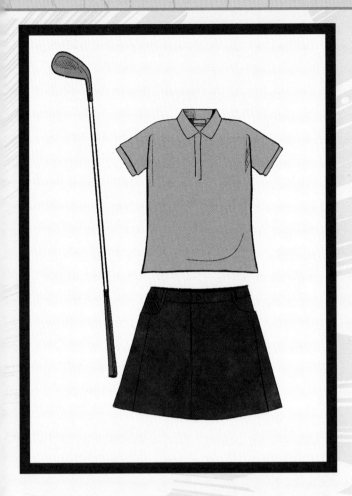

Put together an outfit for a female golf player, starting with a polo shirt and adding a skirt. See pages 96–97 for more ideas on formal golfwear and accessories.

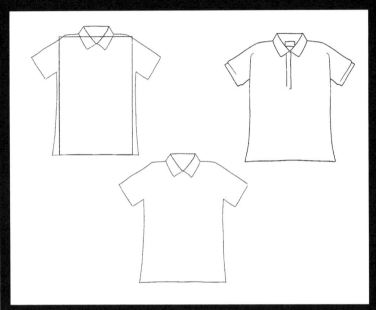

Break down a classic ballet costume into a bodice and tutu, following the instructions on page 99 for how to simplify the shapes.

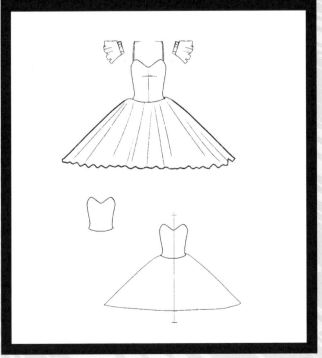

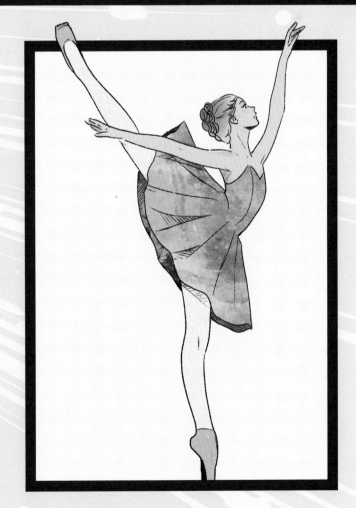

7.
SCHOOL UNIFORMS

High school is the perfect setting for coming-of-age stories, making it a popular subject for manga. To capture the look, you need to study classic Japanese school uniforms, from sailor tops to bobby socks, backpacks to bows.

TAILORED
SMART
NEAT
BOWS
NOSTALGIC

CUTE
PLEATS
EMBLEMS
FUNCTIONAL
PRACTICAL

PREPPY
TRADITIONAL

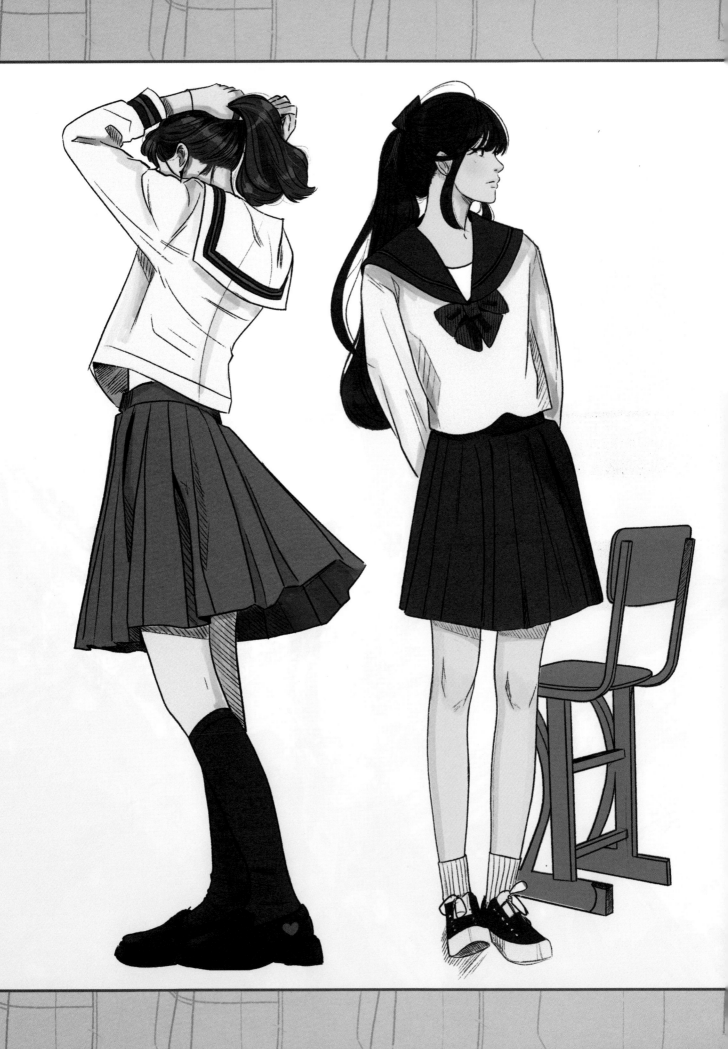

GIRLS' UNIFORMS

The basic school outfit is universally recognisable – a shirt, blazer and skirt or trousers. In Japan, girls' uniforms have a few distinguishing features, with differing skirt lengths, sailor tops and large neck bows, which will instantly give your character a manga high-school look. Have fun exploring the many elements of school style, and don't forget socks and shoes!

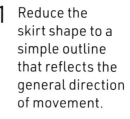

1 Reduce the skirt shape to a simple outline that reflects the general direction of movement.

THE SHORT SKIRT

The pleated gym skirt is perfect for capturing a sense of dynamism and movement; take your time with the direction of the pleats and shape of the hemline, following the steps below.

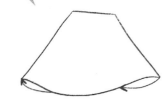

2 Add detail to the hem to give a sense of depth. This area will be shaded in later to suggest the skirt's lining.

3 Next, add vertical lines for the pleats where the fabric is folded back on itself. Make the lines closer at the waist and wider on the hem.

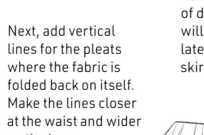

4 Refine the outer edges, shading the inside and adding creases and kinks to the folds in order to give a sense of dynamism.

More of the skirt's lining is visible when seen from different angles.

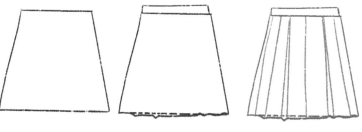

A-LINE SKIRT

To draw a manga school skirt, simply sketch out the basic trapezoid shape, then add the waist and any pleats or style details you want. This universal skirt shape can be adapted with zips, buttons, single or multiple pleats, and even changed into a kilt.

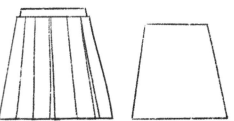

CHANGING HEMLINES

Typically, manga school skirts are short, falling just above the knee but occasionally longer, more old-fashioned styles are worn. The same principles apply as for drawing an A-line skirt (above), just extend the length before adding any pleats or details. Check the proportions against the overall pose.

ACCESSORIES

You can be really creative when it comes to finishing details and accessories. Look out for the subtle choices that differentiate styles and personalities, such as whether the neck is finished with a tie or a bow. The length of socks is also important – try long socks with short skirts, or short socks and loafers.

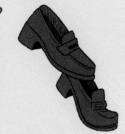

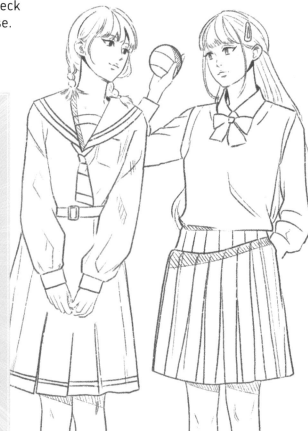

BOYS' UNIFORMS

The school dress code for boys includes many of the same items as for girls, among which are a white or solid-coloured shirt, a jumper and the regulation blazer. However, the overall cut of boys' uniforms is looser, with matching jacket and trousers, and ties rather than bows.

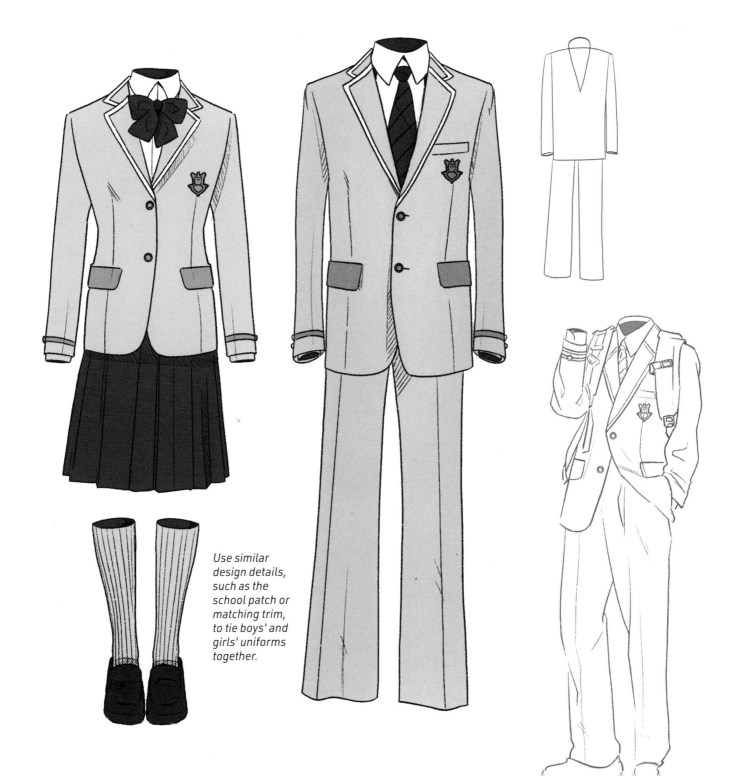

Use similar design details, such as the school patch or matching trim, to tie boys' and girls' uniforms together.

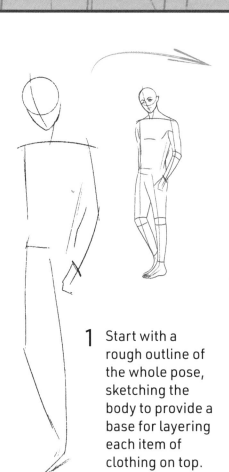

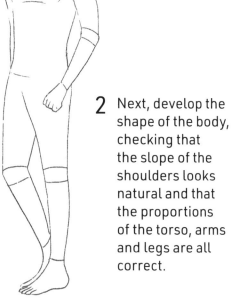

1 Start with a rough outline of the whole pose, sketching the body to provide a base for layering each item of clothing on top.

2 Next, develop the shape of the body, checking that the slope of the shoulders looks natural and that the proportions of the torso, arms and legs are all correct.

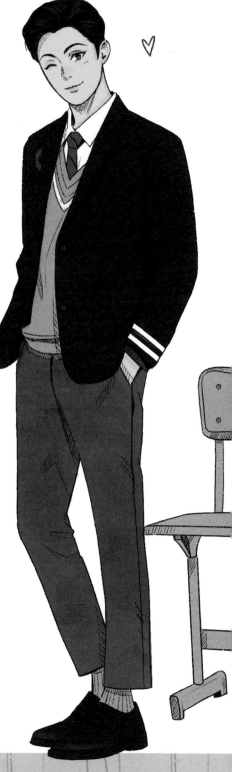

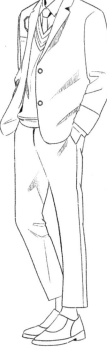

4 Similarly, the trousers follow the shape of the legs, with the hem falling just above the ankle. Add creases and finishing details.

3 Follow the curves of the shoulders to add the clothing, drawing the jacket outside the outline to suggest bulky layers beneath.

MANGA ART SECRET
Get in the habit of sketching the full body for each pose to help get the proportions right, then the clothes will fit too!

BAGS AND BACKPACKS

Used to carry materials to and from school, the schoolbag has an important functional role. However, for manga characters, as for students the world over, the schoolbag is also a fashion statement, where they can showcase their individual style. Follow the steps below to draw a classic backpack that you can customise.

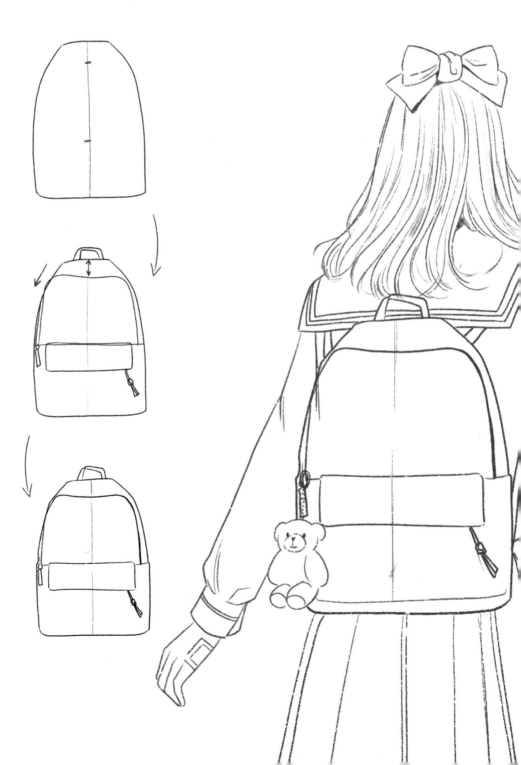

1 First, draw a rectangle and reshape the top corners into matching, symmetrical curves, then round off the bottom corners.

2 Now that you have the basic backpack form, add the different components – a carry loop, pocket flaps and zips – keeping the edges curved and smooth to represent soft fabric.

3 The simple bag shape is now complete and can be used as a template for other designs, with customised elements such as extra pockets, logos, hanging charms, buttons and stickers – anything goes!

To draw a backpack at an angle, start with your rectangle and round off the corners. Note how one bottom corner is a deeper curve where the side of the bag is visible. Use guidelines to help keep pockets and compartments in perspective.

Side angle

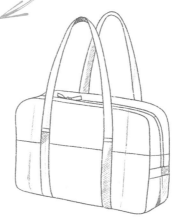

While a backpack is the most popular style of schoolbag, you can choose to accessorise your manga character with anything from a satchel to an oversized handbag or tote.

Follow the steps on the exercise spread (see page 114) to draw a school satchel. Then add a strap from the top handle so that your character can wear it as a crossbody bag.

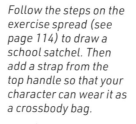

ACCESSORIES

To add more personality to the character, include the items that would go in their bag such as a notebook, pens and water bottle, with headphones and a phone to hand too.

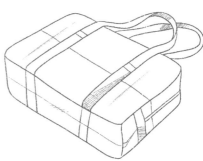

To draw a satchel, start with a rectangle, add a central flap and then buckles and straps with a few cute decorations. See page 112 for how to draw a backpack.

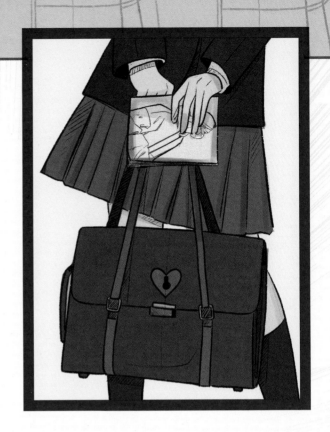

EXERCISE ROUND-UP

Use these exercises to perfect the different elements of a manga school uniform, whether a smart boy's suit or a quirky take on school-girl style.

To draw a preppy-look loafer, use the foot shape as a guide for the upper. Add a chunky heel and the classic band to finish.

Girls' uniforms often include dresses as well as skirts. Follow the principles for drawing a skirt on page 108, adapting it to add a pinafore top layered over a shirt.

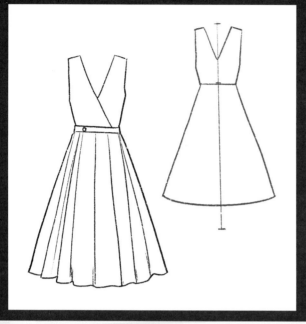

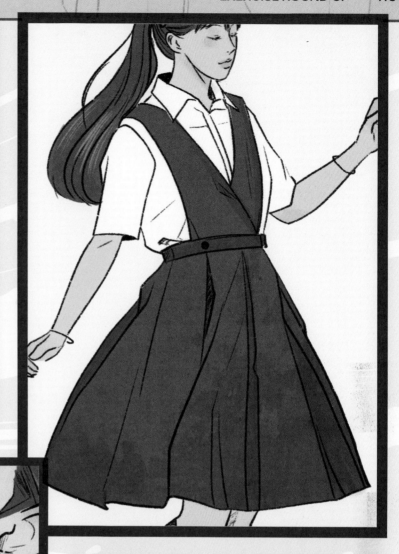

To draw a bow tied at the neck, break the shape down into the smaller components, starting in the centre, adding the loops and then the ends, and keeping it symmetrical.

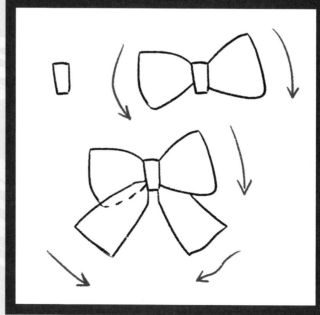

8.

SLEEPWEAR

Rest and relaxation call for comfortable clothing, and new trends in loungewear and sleepwear have brought soft and cosy fabrics into fashion focus. Classic pyjamas are always popular and can be styled in many ways to add some manga cuteness at bedtime.

SOFT	LOOSE	BAGGY
FLUFFY	LACY	CUDDLY
COMFORTABLE	FRILLS	SWEET
PLUSH	HOODS	
RELAXED	MULES	

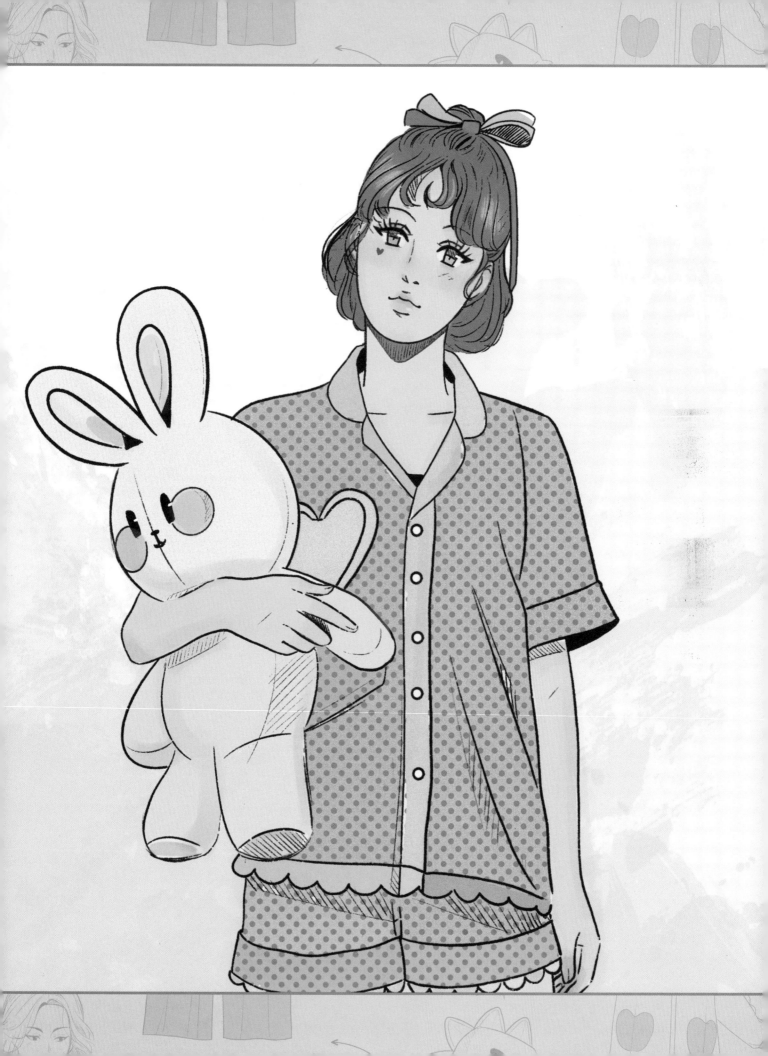

BEDTIME

Pyjamas are a unisex option that are available in different styles. They tend to be loose-fitting and made from soft fabrics, which means that they drape or hang on the body. You don't need to be an expert at figure drawing to clothe your character in pjs or a nightdress, so have fun with cosy styles when bedtime beckons.

THE NIGHTDRESS

Simplify the loose, wide shape of a traditional nightdress into a rectangular outline and add short or long sleeves. Draw the end of the gathered sleeves using small curves connected at regular intervals, for a puffed shape.

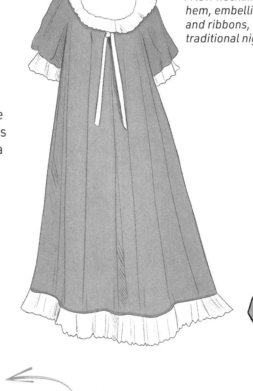

A low neckline and frilled hem, embellished with lace and ribbons, complete a traditional nightdress.

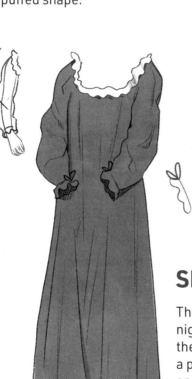

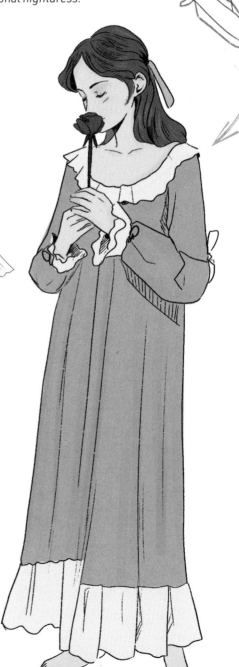

SLEEVES AND CUFFS

The finishing details on many traditional nightwear items are often what gives them their classic look: piped cuffs and a pocket on pjyamas, or frilled hemlines and lacy edging on nightdresses. Because these garments are loose-fitting, the shapes are relatively simple. Reduce a cuff to a rectangle, and look for gentle waves along frilled hems or down the length of a nightdress sleeve.

MATCHING SETS

Male characters look debonair in two-piece classic pjs, while you can have fun with matching sets for female characters, swapping trousers for shorts in cute designs.

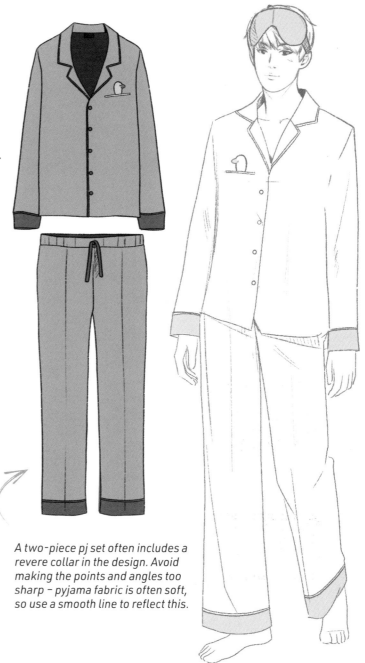

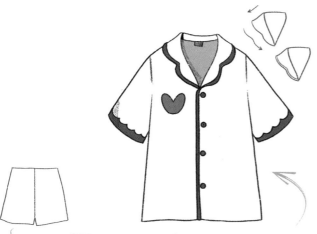

Use simple patterns, such as a scalloped edging, or cute motifs like a loveheart, to show the personality of the character.

A two-piece pj set often includes a revere collar in the design. Avoid making the points and angles too sharp – pyjama fabric is often soft, so use a smooth line to reflect this.

ACCESSORIES

Add some quirky accessories to your character's pose. Try pairing pjs with fluffy slippers and a mug of cocoa, or a long nightdress with a cuddly toy.

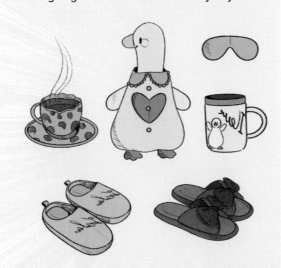

MANGA ART SECRET

Take a simple garment, like a pair of pyjama shorts, and add details to increase the appearance of complexity. These design details can include piped edgings, playful buttons, lace and bows, which can be matched to the shirt or top, or used as a contrast. These details will help to show the personality of your character.

LOUNGEWEAR

The fashion trend known as loungewear is increasingly popular – a mix of day and nightwear, it features loose and comfy pyjama fabrics in casual styles. Start your outfit with pared-back tees, joggers and hoodies (see pages 34, 19 and 28), and enjoy adding design elements that give it a unique manga personality.

See page 34 for how to draw a basic T-shirt. Keep the style loose and oversized, with wide arms.

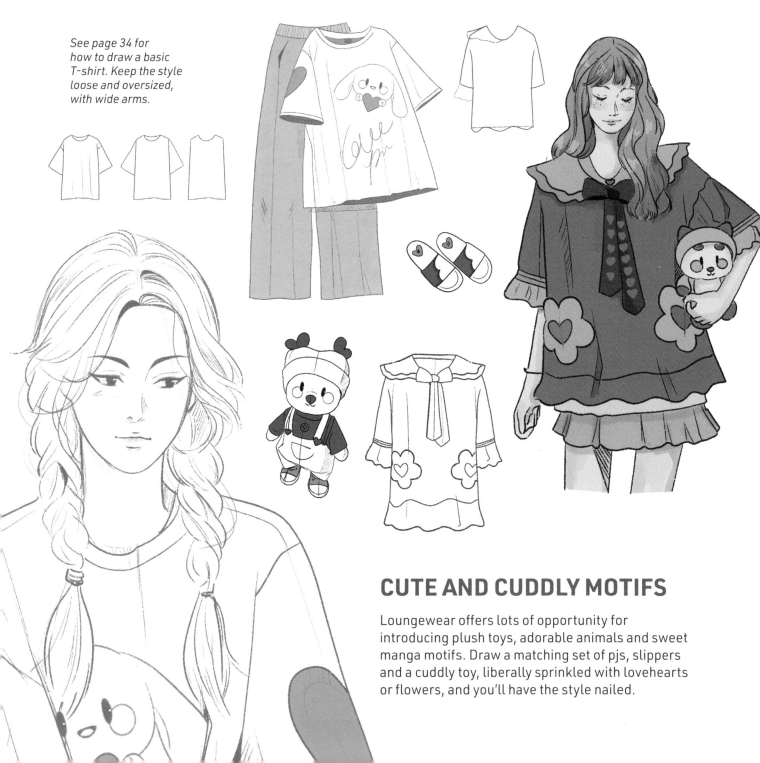

CUTE AND CUDDLY MOTIFS

Loungewear offers lots of opportunity for introducing plush toys, adorable animals and sweet manga motifs. Draw a matching set of pjs, slippers and a cuddly toy, liberally sprinkled with lovehearts or flowers, and you'll have the style nailed.

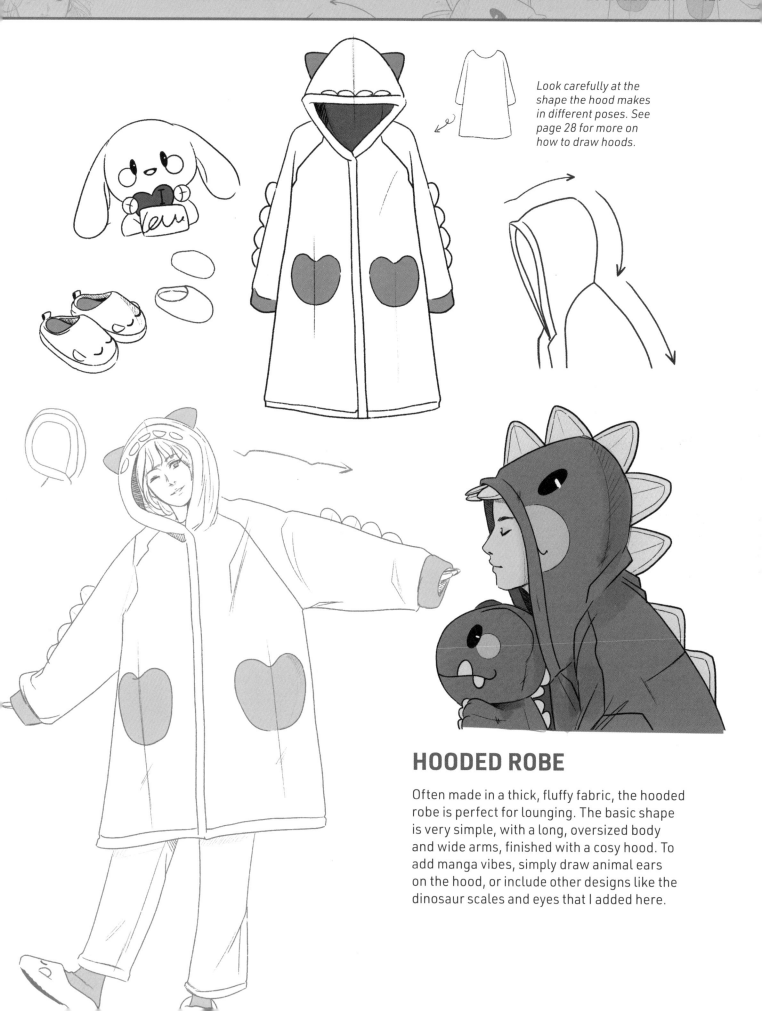

Look carefully at the shape the hood makes in different poses. See page 28 for more on how to draw hoods.

HOODED ROBE

Often made in a thick, fluffy fabric, the hooded robe is perfect for lounging. The basic shape is very simple, with a long, oversized body and wide arms, finished with a cosy hood. To add manga vibes, simply draw animal ears on the hood, or include other designs like the dinosaur scales and eyes that I added here.

To finish a bedtime outfit, practise the simple slipper shape below, using the ideas on page 120 to decorate them with adorable features or motifs.

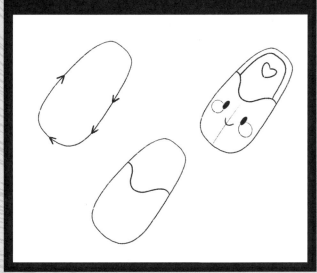

EXERCISE ROUND-UP

Practise drawing each sleepwear item so that you can mix and match styles, creating a cosy outfit that is perfect for lounging at the end of your character's day.

Draw a pair of pj shorts, following the breakdown of steps below. See page 119 for ideas on adding design details.

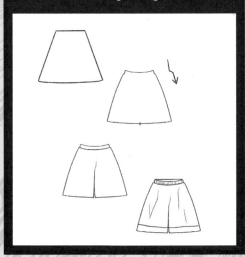

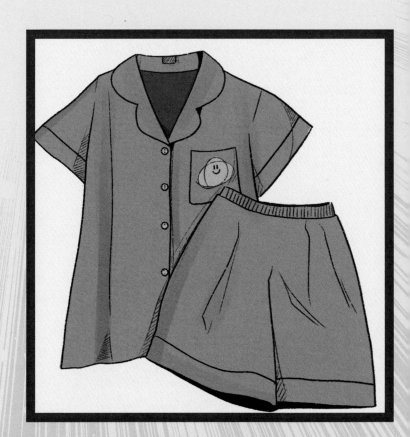

Follow the steps below to draw a classic pyjama top, keeping it symmetrical with a V-neckline, a row of buttons and piped cuffs to finish.

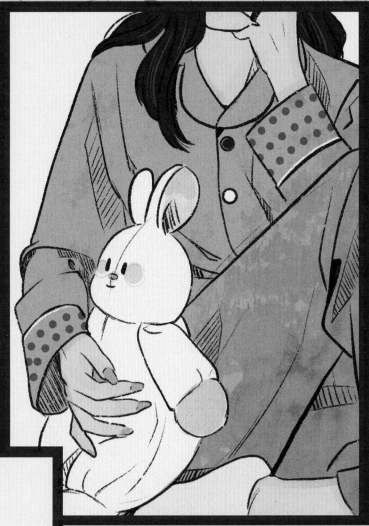

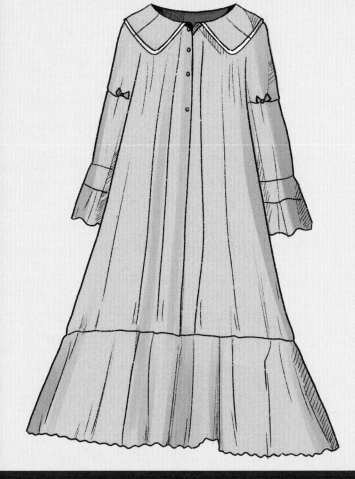

Sketch the A-line shape of a long nightdress using smooth lines and add gathers and folds. See page 118 for more styles.

MORIMACHIKO (@MORIMACHIKO27)

I am an illustrator based in Japan. I work digitally, using an LCD pen tablet. I first became interested in drawing while drawing Pokémon with my friends. Later, manga magazines sparked my interest in anime and manga. The secret of my drawings is that I always want the viewer to find them interesting, so I draw with 'freedom' as my motto, incorporating ideas, experiences and feelings.

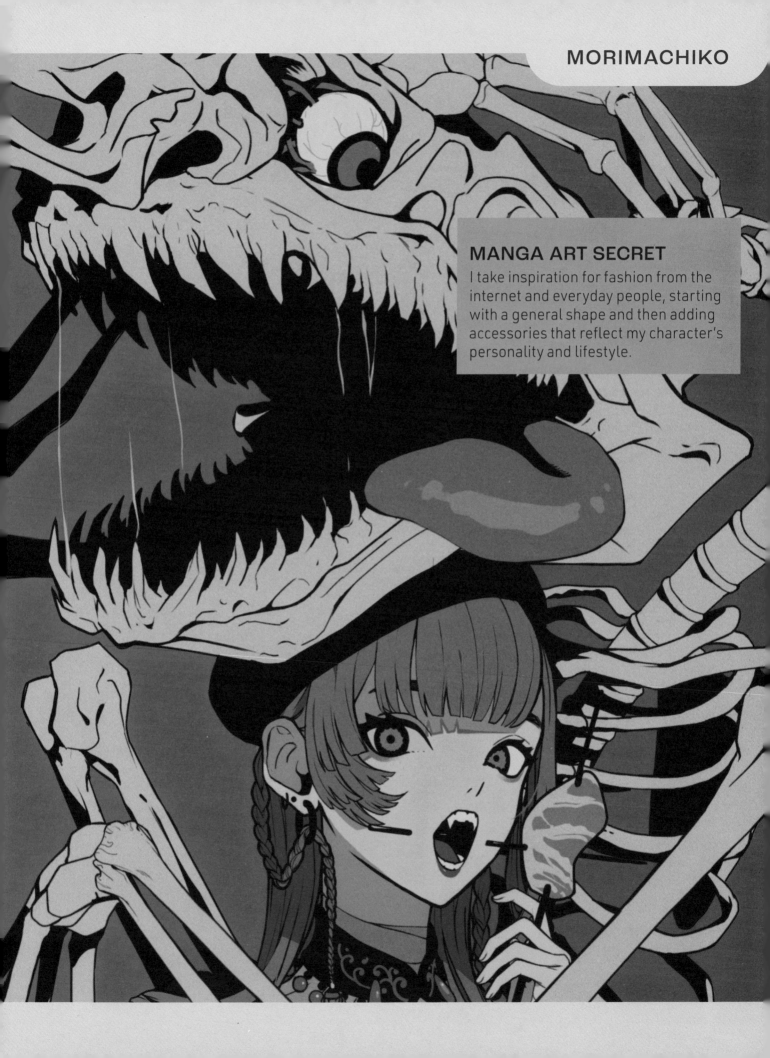

MANGA ART SECRET
I take inspiration for fashion from the internet and everyday people, starting with a general shape and then adding accessories that reflect my character's personality and lifestyle.

INDEX

ACKNOWLEDGEMENTS

I am thankful to all those who contributed to the making of this book!

I am truly grateful for the support I have received from my family, especially from my parents, who fostered my confidence in my drawing abilities from an early age. During the writing process, my twin sister, Diana, and brother, Wael, provided me with a lot of assistance. I would also like to thank my followers on Instagram for always showing so much interest in my drawings and for their support.

This book would not have been possible without Katie, Charlene, India and Martina and all the team at Quarto. I would like to thank all the artists in residence who allowed us to include their work in this book. For me, the opportunity to create this book was an honour, and I am so grateful that it became a reality.

MANGA ARTISTS

Page 48: M. Umair Ali – @MANGAKAUA983

Page 62: Arunyi – @ARUNYI_ / arunyi.art

Page 80: Yuckie – @KIRAIXSUKI / kiraisuki.carrd.co

Page 90: Diana – @DIANA1992D

Page 124: Morimachiko – @MORIMACHIKO27 / @mrmr_m27